lifelike drawing
in colored pencil
with *Lee Hammond*

NORTH LIGHT BOOKS
CINCINNATI, OHIO
www.artistsnetwork.com

About the Author

Polly "Lee" Hammond is an illustrator and art instructor from the Kansas City area. She owns and operates a private art studio called Take it To Art,* where she teaches realistic drawing and painting. Lee also teaches drawing and painting workshops all over the U.S.

Lee was raised and educated in Lincoln, Nebraska, and she established her career in illustration and teaching in Kansas City. Although she has lived all over the country, she will always consider Kansas City home. Since 1994, Lee has authored more than twenty titles for North Light Books. In addition to writing for publications such as *The Artist's Magazine*, Lee is a certified police composite artist and works for the Kansas City Metropolitan Police Department, as well as *America's Most Wanted* and truTV. She also worked seven years as a licensed NASCAR illustrator.

Lee currently lives in Overland Park, Kansas, along with her family. You may contact Lee via e-mail at pollylee@aol.com or visit her website at www.leehammond.com.

*Take it to Art is a registered trademark for Lee Hammond.

Other fine North Light Books are available from your local bookstore, art supply store, online supplier, or visit our website at www.fwpublications.com.

12 11 10 09 08 5 4 3 2 1

DISTRIBUTED IN CANADA BY FRASER DIRECT
100 Armstrong Avenue
Georgetown, ON, Canada L7G 5S4
Tel: (905) 877-4411

DISTRIBUTED IN THE U.K. AND EUROPE BY DAVID & CHARLES
Brunel House, Newton Abbot, Devon, TQ12 4PU, England
Tel: (+44) 1626 323200, Fax: (+44) 1626 323319
Email: postmaster@davidandcharles.co.uk

DISTRIBUTED IN AUSTRALIA BY CAPRICORN LINK
P.O. Box 704, S. Windsor NSW, 2756 Australia
Tel: (02) 4577-3555

Library of Congress Cataloging in Publication Data
Hammond, Lee
 Lifelike drawing in colored pencil with Lee Hammond / Lee Hammond.
 p. cm.
 Includes index.
 ISBN 978-1-60061-037-0 (pbk. : alk. paper)
 1. Colored pencil drawing--Technique. I. Title.
NC892.H363 2008
741.2'4--dc22 2008009939

Edited by Sarah Laichas and Mona Michael
Designed by Wendy Dunning
Production coordinated by Matt Wagner

METRIC CONVERSION CHART

To convert	to	multiply by
Inches	Centimeters	2.54
Centimeters	Inches	0.4
Feet	Centimeters	30.5
Centimeters	Feet	0.03
Yards	Meters	0.9
Meters	Yards	1.1

Mel "Tice" Theisen
Stonehenge paper
11" × 14" (28cm × 36cm)

Dedication

This book belongs to Mel "Tice" Theisen. A more patient and kind person you will never find! His wonderful support in all that I do, and help with anything I could possibly need, gives me the freedom to reach for the stars. Also, being able to work from his awesome photography helps make me look better than I really am. Anyone who knows me will surely agree that I am a much better person for having him in my world. For all those things, I am forever grateful!

I also want to thank and acknowledge my sister, Cathi, who has artistically inspired me my whole life. She is a gifted artist (better than me, in my opinion!), and has always been, in many ways, my mentor. She still does not fully understand the wonderful influence she has had on my artistic career. When I was a child, watching her create her artwork was truly magical, and the need to create was passed on to me.

Acknowledgments

This book is also dedicated to all my students who come to my studio week after week, month after month, and year after year, and honestly help keep me sane. (No easy task!) I am in awe of your constant loyalty and heartfelt friendships. I cannot imagine life without you and our time together. My studio is truly a healing place where life gives us a tiny glimpse of heaven. Some say that room is the world's best-kept secret! Here's to many, many more years together, solving all the world's problems in our favorite room!

Also, I would be remiss if I didn't mention my wonderful publishing company. North Light Books has been my home for more than fifteen years now. I have had the opportunity to work with some of the best editors in the industry. Without their expertise and professional guidance, my books would not be as successful as they are. They have meant the difference between mediocrity and awesomeness, and I couldn't begin to thank them enough. To all the wonderful editors I have had the pleasure of working with, thank you, from the bottom of my heart. I'm already looking forward to next time!

Table of Contents

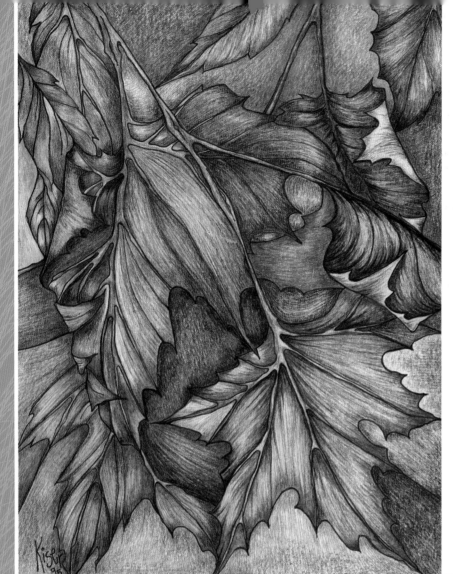

Realism Meets Personal Flare

My sister, Cathi, is an awesome artist, and I want the world to see a sample of her beautiful work. This drawing is a wonderful representation of realistic colored pencil.

Fall Leaves
Drawing by Cathi Kiser
Mat board
12" × 8" (30cm × 20cm)

Introduction

When I was younger and experimenting with my natural urge to draw, I created some pretty wild images. I was raised in the 60s and 70s, when the trend in art was using bright, flashy colors and psychedelic impressions. It was called pop art and was fantastically fun, especially when viewed under a black light where the colors turned neon and seemed to glow. I spent hours drawing and painting fun things in the craziest designs possible. Everything in art was loud and exaggerated, much like my personality back then.

Later, however, when I entered my late teens, I felt the need to be more realistic. I abandoned my wild designs, and tried desperately to capture on paper life as I really saw it. It wasn't easy, but I discovered that my natural artistic self was that of a realist.

When studying art history in school, I fell in love with the works of sixteenth-century Europe. The awesome realism captured by Michelangelo, Rembrandt, Rubens and Renoir fueled my desire to do the same. My journey had begun! To this day, I try to go to as many art galleries and museums as possible to study original masters' works. I also take my students to the Nelson-Atkins Museum here in Kansas City, Missouri, to discuss the techniques and analyze the colors and brush strokes up close. Many don't know that I am an oil painter as well, and I try to replicate the beauty I see in my favorite artists' artwork from the past.

This book is all about creating realism in your own artwork. It isn't easy, and it requires great patience. If you put in the time, your work will take on a colorful, multi-dimensional quality that every realist craves.

Practice the projects in this book one at a time, in the order in which they appear. It will give you the training you need to begin to fully develop your colored pencil skills.

About Colored Pencil

Colored pencil can be daunting. I have written many books on the subject, and have learned more and more with each one. In previous books, I used a variety of brands and types of colored pencils. It was fun experimenting, but a bit confusing to the reader and the students trying to follow my techniques.

For that reason, I have chosen to simplify this book by using only one brand: Prismacolor. You will have no problem finding Prismacolor pencils in your local art and hobby stores. They are of excellent quality and will give you fantastic results.

When I first tried colored pencil drawing myself, it was disastrous. My efforts rendered something resembling a kindergartner's crayon drawing, and had none of the realism that I had achieved in my graphite drawings. Needless to say, it was frustrating and a huge blow to my artistic ego. I blamed myself for being untalented and put my set of colored pencils away. I returned to graphite drawing, which I had honed into my creative comfort zone.

A couple of years later, something in my brain clicked, and I woke up one day wanting to try them again. I realized in the recesses of my mind that I had simply been applying them incorrectly. In the pages that follow, I'll share with you my experiences, and how I worked through various obstacles.

You can get completely different looks with colored pencils depending on how you apply the color. Light, layering application gives you texture; heavy, burnished applications fill in the bumps and grooves of the paper, giving the art a smooth, almost painted appearance and a shiny surface. It is this versatility that makes colored pencil a wonderful medium for capturing many different looks.

Colored pencil is now one of my favorite mediums! Welcome to the wonderful experience of colored pencil. Let me help make it one of your favorites as well.

Colored Pencil Provides Variety

Study the two different types of fruit in this illustration. The one on the left is a peach, while the other is a nectarine. Both were drawn with the same pencils and the same colors, yet they look completely different! The peach was applied using the layering technique, giving it a fuzzy, textured appearance. The nectarine was burnished, filling in the paper to make the fruit's skin look shiny.

Peach vs. Nectarine
Stonehenge paper
5" × 7" (13cm × 18cm)

You Can Do It!

A few years ago when I was writing a book about birds, my daughter wanted to draw one, too. I gave her a photo out of my reference file and let her give it a try. She was sixteen at the time and had little practice drawing with colored pencil. As you can see by her first attempt, much of her "crayon training" as a child resurfaced, and the drawing came out looking less than refined. As an experienced teacher, I knew that all she needed was a little guidance, and a better understanding of colored pencil application.

Her second attempt looks a lot more professional. By understanding the technique better than before, and applying some accuracy to her shapes, her drawing takes on a much more realistic appearance. Good job, LeAnne!

The moral of this story is … you can do it, too! All you need is a little guidance and some practice to undo the old memories of drawing with crayons. Colored pencil doesn't have to be intimidating once you get the feel of it. For me, it went from a frustrating experience to one of my favorite things to do. It doesn't happen overnight, but rather with persistence and solid practice. Not everything you do will be perfect and ready for hanging on the wall, so go easy on yourself. It's just part of the process of learning. (I have many trash cans in my studio, and I'm not afraid to use them.) In time, you'll be pleasantly surprised!

Drawings by LeAnne
Hammond, age 16

Before

This is a typical example of a beginner's first attempt at colored pencil. If your drawings resemble this, don't worry!

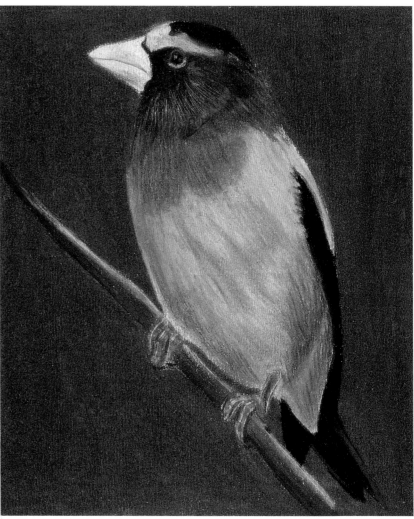

After

After I showed LeAnne how to improve her shapes and technique, her drawing became much more realistic. She now loves to draw with colored pencils.

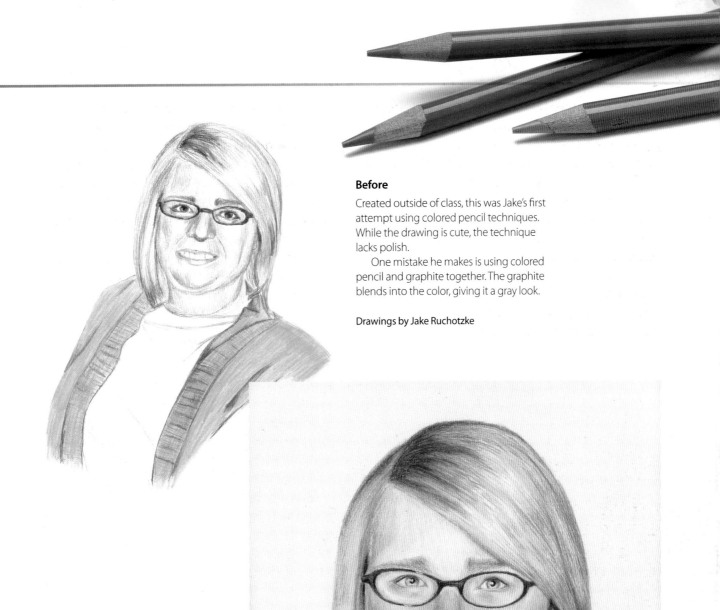

Before

Created outside of class, this was Jake's first attempt using colored pencil techniques. While the drawing is cute, the technique lacks polish.

One mistake he makes is using colored pencil and graphite together. The graphite blends into the color, giving it a gray look.

Drawings by Jake Ruchotzke

After

This is Jake's second attempt after my instruction. The colors have been applied more evenly, and the drawing looks much more refined. Jake drew the face larger on the page for a better composition, which makes it look more like a portrait instead of a sketch. This portrait is a real success story.

Getting Started

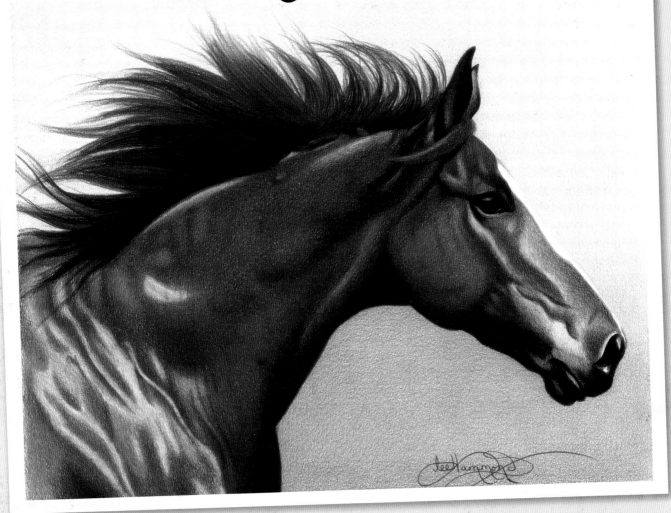

Getting started with colored pencil does not require you to go out and buy a huge range of colors in an expensive boxed set. If you have never drawn with them before, start slow. Begin with just a few colors at first and buy more as you continue. On page 19, you can see a drawing I did with just two colors. The portrait of Tice takes on the look of an old sepia-colored photo. But, because I used just a brown and black pencil, it didn't require a lot of supplies to complete. Look for a reference that will lend itself to this technique, and ease yourself slowly into colored pencil. By going this route first, you can hone your technique without being bogged down by color theory.

Start With Fewer Colors

This drawing of a horse was completed with only seven colors. It does not take many colors to render beautiful drawings. As you get more comfortable with colored pencil techniques, you can expand your pencil palette to include more colors.

Colors Used

Orange, Terra Cotta, Dark Umber, Tuscan Red, Non-Photo Blue, True Blue, Black

Horse in Motion
Stonehenge paper
12" × 16" (30cm × 41cm)

the pencils

Each brand of colored pencil creates a unique look on paper. I can't easily answer which pencil is the best to use or which one I like the most. That really depends on the final outcome and overall look I wish to achieve.

To keep it simple, I'm using only Prismacolor pencils in the examples and demonstrations of this book. However, feel free to experiment and find the colored pencils that work best for you. By using a combination of pencils, you can create a lot of variety to the techniques used in the following pages.

Prismacolor carries richly pigmented, wax-based colored pencils in more than 132 different pigments. The thick, soft, wax-based lead allows you to lay down heavy layers of color. They are opaque (meaning you can't see through them), and can completely cover the paper's surface. The colors can be easily blended to produce an almost painted appearance in your work, or applied gradually and evenly with a very sharp point for a more layered look.

Pencils come in a variety of set sizes. Buy enough pencils to practice some simple drawings, and then add to your color selection as needed. As your collection grows, you can create a system to keep them organized. I place my pencils into color groups, bind them with a hair tie or rubber band, and keep them in an old brief-

case. This may not be the fanciest way of doing things, but it works for me. And if I need to take them with me, I close the briefcase, and off I go!

Prismacolor Pencils
Prismacolor pencils have a thick, soft, wax-based lead that provides a heavy application of color. They are excellent for achieving smooth, shiny surfaces and brilliant colors. The colors can be easily blended to lend an almost painted appearance to your work.

materials for working in color

As with anything, the quality of your colored pencil art-work is determined by the quality of the tools you employ for the job. The following is a list of supplies you will need to succeed.

PAPER

Quality paper is critical. There are many fine papers on the market. As you try various types, you will develop your personal favorites.

Before you try a paper, always check the weight. Many papers are just too thin. I learned this the hard way after a beautiful drawing of my daughter formed a permanent crease when I picked it up. No amount of framing kept my eye from focusing on it first. So, you don't want paper that easily bends when you pick it up.

- Artagain by Strathmore is 60-lb. (130gsm) cover-weight paper that comes in a variety of colors, has a somewhat flannel, speckled appearance and a surface with no noticeable texture. It is available in both pads and single sheets for larger projects.
- Renewal by Strathmore is very similar to Artagain, but has the look of fibers instead of speckles. I like it for its soft earth tones.
- Crescent Mat Board is my personal favorite because of the firmness. It doesn't have to be taped down to a drawing board, making it easy to transport.
- Crescent Suede Mat Board is another favorite of mine. It has a surface like suede or velveteen. Prismacolor pencils look like pastel when applied to this fuzzy surface. It comes in a variety of colors and can be purchased at your local frame shop.

PENCIL SHARPENERS

Many colored pencil techniques require a very sharp point at all times, making pencil sharpeners an important tool. An electric sharpener or battery-operated one allows you to insert the pencil straight on, reducing breakage. Handheld sharpeners require a twisting motion that tend to break pencil points. If you prefer a handheld sharpener, purchase a quality metal one with replacement blades.

ERASERS

Although colored pencil is very difficult, if not impossible, to completely erase, erasers can be used to soften colors. Here are the three you will need for colored pencil:

- Kneaded erasers are like squishy pieces of rubber, good for removing your initial line drawing as you work. They will not damage or rough up your paper surface.
- Pink Pearl erasers are good for general cleaning and large areas, such as backgrounds. These, too, are fairly easy on the paper surface.
- Typewriter erasers look like pencils with little brushes on the end. Highly abrasive, they're good for removing stubborn marks. They can also be used to get into tight places or to create clean edges. Be careful, though; these can easily damage the paper and leave a hole.

MECHANICAL PENCILS

These are great for initial line drawings. Because the lines are so light, they are easily removed with kneaded erasers, unlike ordinary drawing pencils. As you work, replace the graphite lines with color.

ACETATE GRAPHS

Acetate graphs are overlays to place over your reference photos. They have grid patterns on them that divide your picture into even increments, making it easier to draw accurately.

I use them in both 1" (2cm) and ½" (1cm) divisions. They are easy to make using a permanent marker on a piece of acetate. You can also draw one on paper and have it copied to a transparency on a copy machine.

Various Art Supplies

Create Long Pencils With Super Glue

Create a collection of elongated pencils by gluing an old one to a new one. Take what is left of the pencil and add a drop of super glue to the tip of a new, unsharpened pencil, and put the two together. (Only super glue works.) Run another drop around the joint for additional strength, and allow it to dry overnight. Make sure you hold the extended pencil closest to the sharpened end so it doesn't snap apart. You can even sharpen right through the joint therefore extending the life of your pencils!

TEMPLATES

Templates are stencils that are used to obtain perfect circles in your drawing. Use them to get pupils and irises accurate.

REFERENCE PHOTOS

For practice, the best source for drawing material is magazines. Tear out pictures of every subject and categorize them into different bins for easy reference. Don't replicate the exact images, just use them for practice.

CRAFT KNIVES

Craft knives can be used as drawing tools. The edge of the knife can gently scrape away color to create texture such as hair or fur. A knife can also be used to remove unwanted specks that may appear in your work. Take care with this approach to avoid damaging the paper surface.

FIXATIVES

Spray fixative binds your artwork to the drawing surface. I use two different types of finishing sprays.

- Workable fixative is undetectable when applied. Though you can continue drawing with graphite and charcoal once the spray has been applied, you cannot with colored pencil. The wax in Prismacolor pencils actually rises to the surface, making the colors appear cloudy and dull. Workable fixative behaves as a resist, stopping this blooming effect and making the colors true again.
- Damar varnish gives a high-gloss shine to Prismacolor drawings, making it look like an oil painting and the colors shiny and vivid. (Its primary use is to seal oil paintings.) This is great for drawings of fruit, flowers and portraits.

DRAFTING BRUSH

Colored pencil leaves specks of debris as you work that can create difficult-to-erase smudges if left on the paper or brushed away by hand. A horsehair drafting brush gently cleans your work area without smudging your art.

PENCIL EXTENDERS

These handy little tools are great for holding a short pencil. The additional length they provide allows you to keep going, and gives you more length to stick into a pencil sharpener. It not only extends the length, it extends the life of the pencil.

COLOR FINDER

Use this homemade tool to identify and match the color in your drawing to the color in the reference photo. See the caption at left for instructions.

Match Your Colors With a Simple Color Finder

Punch one hole into two plain white pieces of paper or index cards. Place one hole over your reference photo or image to help you focus on the color. Place the second hole over your artwork to help you match the color.

color swatches

The following pages show the variety of colors available in the Prismacolor line. Each swatch shows the color as it looks applied heavily, (on the left side of the swatch) and how it looks with a light touch (on the right side of the swatch).

Use these swatches for color references as you draw. They will help you decide which ones to choose in your drawings.

Warm Colors

Most of the colors on this page, with the exception of the last row, are considered *warm* colors.

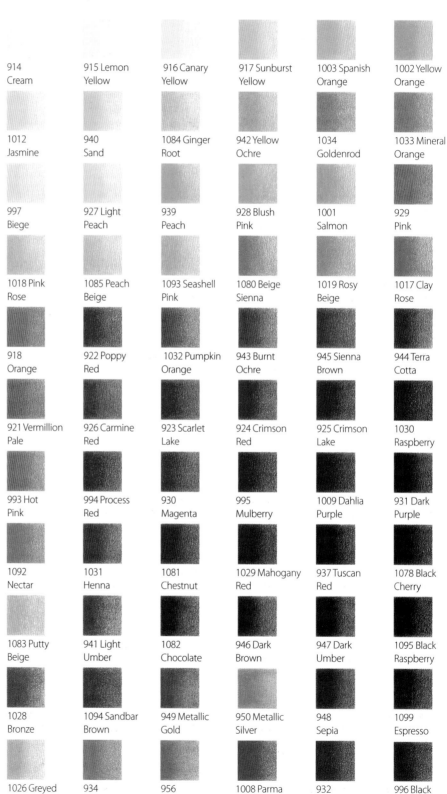

914 Cream	915 Lemon Yellow	916 Canary Yellow	917 Sunburst Yellow	1003 Spanish Orange	1002 Yellow Orange
1012 Jasmine	940 Sand	1084 Ginger Root	942 Yellow Ochre	1034 Goldenrod	1033 Mineral Orange
997 Biege	927 Light Peach	939 Peach	928 Blush Pink	1001 Salmon	929 Pink
1018 Pink Rose	1085 Peach Beige	1093 Seashell Pink	1080 Beige Sienna	1019 Rosy Beige	1017 Clay Rose
918 Orange	922 Poppy Red	1032 Pumpkin Orange	943 Burnt Ochre	945 Sienna Brown	944 Terra Cotta
921 Vermillion Pale	926 Carmine Red	923 Scarlet Lake	924 Crimson Red	925 Crimson Lake	1030 Raspberry
993 Hot Pink	994 Process Red	930 Magenta	995 Mulberry	1009 Dahlia Purple	931 Dark Purple
1092 Nectar	1031 Henna	1081 Chestnut	1029 Mahogany Red	937 Tuscan Red	1078 Black Cherry
1083 Putty Beige	941 Light Umber	1082 Chocolate	946 Dark Brown	947 Dark Umber	1095 Black Raspberry
1028 Bronze	1094 Sandbar Brown	949 Metallic Gold	950 Metallic Silver	948 Sepia	1099 Espresso
1026 Greyed Lavender	934 Lavender	956 Lilac	1008 Parma Violet	932 Violet	996 Black Grape

Cool Colors

Most of the colors on this page, with the exception of the warm and French Greys, are considered *cool* colors.

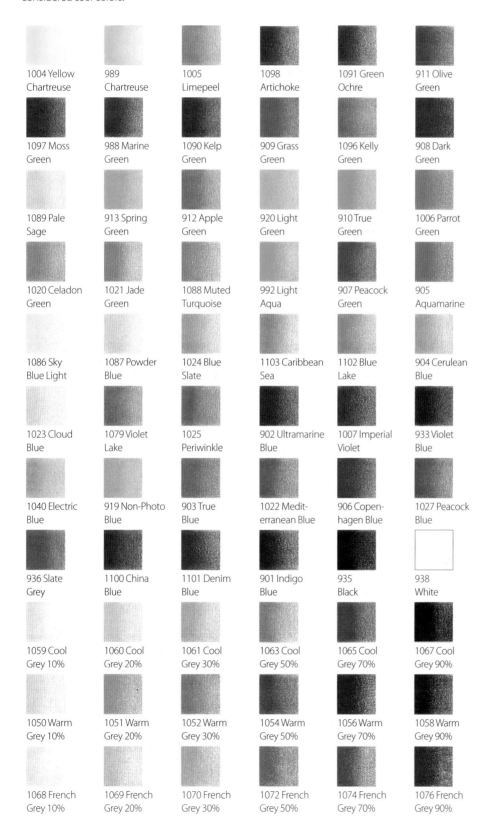

1004 Yellow Chartreuse	989 Chartreuse	1005 Limepeel	1098 Artichoke	1091 Green Ochre	911 Olive Green
1097 Moss Green	988 Marine Green	1090 Kelp Green	909 Grass Green	1096 Kelly Green	908 Dark Green
1089 Pale Sage	913 Spring Green	912 Apple Green	920 Light Green	910 True Green	1006 Parrot Green
1020 Celadon Green	1021 Jade Green	1088 Muted Turquoise	992 Light Aqua	907 Peacock Green	905 Aquamarine
1086 Sky Blue Light	1087 Powder Blue	1024 Blue Slate	1103 Caribbean Sea	1102 Blue Lake	904 Cerulean Blue
1023 Cloud Blue	1079 Violet Lake	1025 Periwinkle	902 Ultramarine Blue	1007 Imperial Violet	933 Violet Blue
1040 Electric Blue	919 Non-Photo Blue	903 True Blue	1022 Mediterranean Blue	906 Copenhagen Blue	1027 Peacock Blue
936 Slate Grey	1100 China Blue	1101 Denim Blue	901 Indigo Blue	935 Black	938 White
1059 Cool Grey 10%	1060 Cool Grey 20%	1061 Cool Grey 30%	1063 Cool Grey 50%	1065 Cool Grey 70%	1067 Cool Grey 90%
1050 Warm Grey 10%	1051 Warm Grey 20%	1052 Warm Grey 30%	1054 Warm Grey 50%	1056 Warm Grey 70%	1058 Warm Grey 90%
1068 French Grey 10%	1069 French Grey 20%	1070 French Grey 30%	1072 French Grey 50%	1074 French Grey 70%	1076 French Grey 90%

LEE'S LESSONS

It is important to understand the traits of warm and cool colors. Warm colors are often used to reflect light off of subjects and appear to come forward. Cool colors are often used in shadows and appear to recede.

Study finished art and note how the artist uses warm and cool colors to create the piece's light source and center of interest.

15

2 Techniques

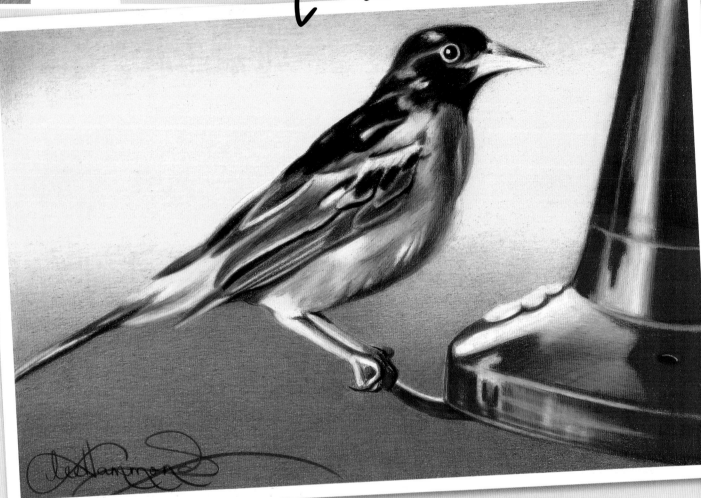

There are two basic techniques that you'll need to know for working with Prismacolor colored pencils: layering and burnishing. Choose your approach depending on the subject matter you are attempting to capture, or the look or texture you're trying to evoke.

In many cases, a drawing will require you to combine techniques. Analyze the variety of surfaces in your piece and decide whether to use layering, burnishing or both to create them. Burnishing can be very useful for shiny objects or for fixing a flat background. If you are near the completion of a layered project and you feel something is missing, burnish the background to make your subject matter pop from the page.

Baltimore Oriole on a Hummingbird Feeder
Stonehenge paper
8" × 10" (20cm × 25cm)

Bouncing and Reflecting Colors

Not only can the use of color change the way something looks, color can actually bounce around and attach itself to objects. This Baltimore Oriole likes to come and drink the nectar we put in our hummingbird feeder. In this drawing, I captured the bright red color of the feeder reflecting the brilliant yellow color of the bird.

Look around you and see if you can see color bouncing and reflecting off objects and surfaces in your home.

Colors Used

Canary Yellow, Lemon Yellow, Orange, Poppy Red, Carmine Red, Crimson Red, Light Umber, Cool Grey 30%, Yellow Chartreuse, Chartreuse, Apple Green, Black, White

putting pencil to paper

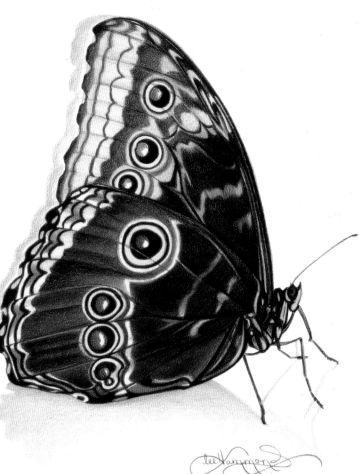

Sometimes it is not easy to decide whether to layer or burnish. The good thing is, if you begin with layering, you can always choose to deepen your tones and burnish an area if it doesn't turn out the way you want. In most cases, a drawing will require both techniques, since the surfaces of people, places and things are all so different.

These butterflies are drawn using two entirely different techniques, and each one has a unique look.

Layered Butterfly

This approach shows off the powdery look of the blue morpho butterfly. You can see the texture of the paper coming through, helping the colors look less filled in.

Colors Used

Dark Brown, Dark Umber, Black Raspberry, Poppy Red, Seashell Pink, Greyed Lavender, Peacock Blue, Copenhagen Blue, Black, White

Burnished Butterfly

This monarch butterfly is much more vivid in color, and the powdery nature of the wings is not as evident. Burnishing makes the colors brighter and more intense. To make it stand out even further, I chose to fully develop the background with bright colors.

Colors Used

Canary Yellow, Terra Cotta, Raspberry, Light Peach, Sand, Lavender, Process Red, Aquamarine, Grass Green, Violet Blue, Periwinkle, Black, White

layering

All colored pencil drawings begin with layering. It is done by applying the pencil with light layers, keeping a sharp point on the pencil at all times. The hallmark look of layering is when the texture of the paper shows through the pencil, giving it a somewhat grainy appearance. With the layering technique, you will also be able to see your pencil strokes, giving your works a more hand-drawn appearance.

Always remember, it requires patience to build the tones. Hurrying with colored pencil will create an unevenness in the application and ruin the look of your drawing. Do not overlap too many different colors, or they will build up and become opaque.

 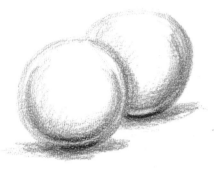

Step 1

Lightly draw two spherical stones on your drawing paper with a mechanical pencil.

Step 2

With Sandbar Brown and a sharp point, add some color to the stones. This is their undertone. With Cool Grey 70%, create the shadow edges to make the stones appear round (see more instruction on spheres on page 28). Make sure to leave the small area of reflected light showing along the edges. Use a light touch when applying the colored pencil, and allow the paper texture to show through. Do not build up the tones too heavily.

With Cool Grey 70% and Black, create the cast shadow beneath the stones.

Step 3

Add a small amount of Sand over the other colors to darken the stones. Add some of this color below the cast shadow as well. Practice creating this soft, layered look on other types of objects.

Colors Used
Sandbar Brown, Sand, Cool Grey 70%, Black

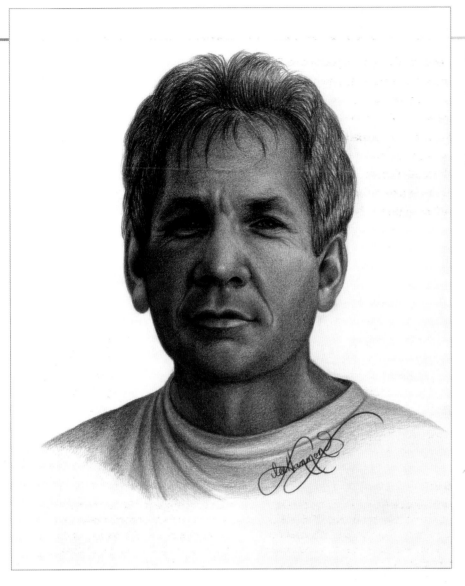

Layering Requires Patience

Using the layering technique requires patience, especially to create deep tones, but it's well worth it for these results. This portrait of Mel "Tice" Theisen was created on ivory-toned mat board with just two tones.

Colors Used
Dark Brown, Black

Layering in Color

When layering in color, make sure you don't overlap the colors to the point that they become opaque. Again, you should see the graininess of the paper showing through the colored pencil.

Colors Used
Poppy Red, Crimson Red, Tuscan Red, Blue Violet, Indigo Blue, Limepeel, Grass Green, Dark Green, Yellow Chartreuse, Yellow Ochre, Dark Brown, Canary Yellow, Orange, Light Aqua, Aquamarine, Black, White

burnishing

When you burnish, you apply colored pencil heavily with a firm pressure that makes the pigment totally cover the paper surface. Because of the wax content of Prismacolor pencils, the pigment goes on with a creamy feel, and the colors become very opaque with the heavy pressure. This can make the colored pencil mimic the look of oil painting, with bright colors and a shiny impression. Many of the subjects I used to paint in oils I now do in colored pencil with similar results.

When you burnish layers of pencil, the colors mix together like paint instead of remaining independent. The texture or grain of the paper is flattened by the pencil pressure, and the pigment and wax of the pencil fill it in completely. When practicing this technique, use pencils with a bit duller point to balance out the heavy pressure of application.

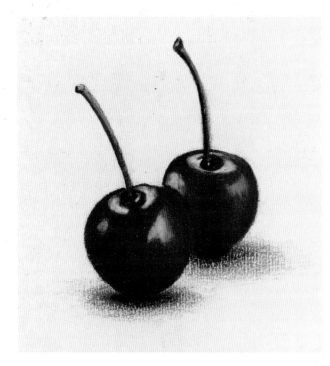

Step 1

Lightly draw the cherries' shapes with a mechanical pencil. With a light touch and Carmine Red, layer the undertone of the cherries. Draw in the shadow edges of the cherries with Crimson Lake. (Refer to the sphere exercise on page 28 more instruction.) Add a hint of the cast shadow below them with Black.

Step 2

Using the same colors as in step 1, reapply the colors using a heavier touch. Use enough pressure that the colors completely fill in the paper and it is no longer visible.

Start with Carmine Red, the undertone of the cherries. Be sure to leave the light area of the highlight open. Deepen the color of the shadows and curves with Crimson Lake. Deepen the color of the shadow edges with Dark Purple. Be sure to allow an edge of reflected light to still show through. Just like the sphere exercise, this makes them look more rounded.

With Black and a sharp point, create the left side and base of the cherry stems.

Step 3

Continue deepening your tones using firm pressure so the colors burnish together. With White, fill in the highlight areas to make the surface look shiny. Add Yellow Ochre to the right side of the cherry stems. Add a small amount of Crimson Lake over the Yellow Ochre on the right side as well. This is called reflected color, which is bouncing up from the cherries below.

To complete the drawing, enlarge the cast shadows below the cherries with Black. The direction of the shadows tells us the angle of the light source. Add a small amount of Yellow Ochre to the cast shadow to make it appear more realistic.

Colors Used
Carmine Red, Crimson Lake, Dark Purple, Yellow Ochre, White, Black

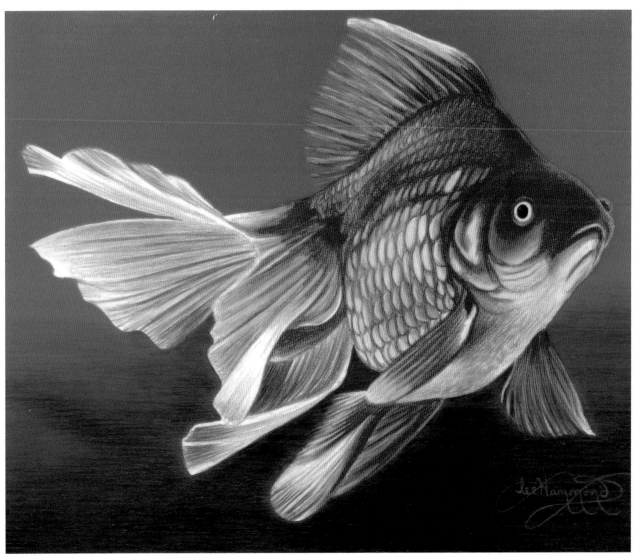

Burnishing in Action

Rich, bright hues, colored background and complementary colors do a lot to help this fantail goldfish stand out, but it's the burnishing that really gives it shine and helps create the texture of the scales.

Colors Used

Canary Yellow, Orange, Poppy Red, Scarlet Lake, Aquamarine, Parrot Green, True Blue, Denim Blue, Black, White

LEE'S LESSONS

You may notice a milky haze forming on your drawing as you burnish with wax-based colored pencils. The colors will look like they have a filmy coating over them. This is perfectly normal. It is just the wax of the pencil separating from the pigment and rising to the surface. You can buff it a bit with your finger or a tissue and it will go away; however, it will soon return. To correct this problem, it is important to spray your drawing with a fixative when you are finished. This seals the color, and prevents the wax from separating.

Beware, though! Fixative alters the surface of the paper, affecting the way the pencil is applied. Spray your work only when you are entirely finished with it.

value scales/gradation

Regardless of which technique you are using when applying colored pencil, the pressure you apply is the most important part. Learning how to control your pressure to create an even application of tone is crucial to good colored pencil work.

While drawing value scales is not very exciting, it is a very important skill to know. It is the gradual application of tone that makes things look realistic. The drawing below is a great example of soft, subtle tonal changes.

Look at these value scales. You can see the difference the application makes when it comes to how the colored pencil works. Each of these was created with Dark Brown, but the way the color was applied to the paper makes them all look very different.

Incorrect Gradation

Gradation of tone is essential for good work. This looks choppy and very much like crayon.

This example shows what usually happens when someone is new to colored pencils. The pencil strokes are way too visible and uneven for this to look good.

Correct Gradation

This is an example of a well-executed value scale. This was done with both burnishing and layering using very controlled pencil lines so the tones are even and full. This makes the tone gradual, with the tones gently fading from dark to light with no choppiness. Keep practicing to make your scales look like this. It is simply a matter of getting the "feel" of the pencil. Apply more pressure in the dark areas, and then gradually lighten your touch for the lighter areas.

The Surface Can Affect Your Tones

This is also a well-executed gradation using the same color, but on suede board instead. You can see how the texture of the board not only changes the appearance, but seems to change the color as well.

Before you begin any project, test your colors on a scrap of the paper or board you are using to be sure of their appearance.

about color

A good understanding of colors and how they work is essential to drawing. It all begins with the color wheel, which shows how colors relate to one another.

PRIMARIES AND SECONDARIES

There are three primary colors: red, yellow and blue. They are pure colors. Mixing these colors in different combinations creates all other colors. Mixing two primary colors makes a secondary color; for instance, red mixed with yellow makes orange. Secondary colors can be found in between the primary colors on the color wheel.

WARM AND COOL COLORS

The warm colors consist of yellow, yellow-orange, orange, red-orange, red and red-violet. The cool colors are violet, blue-violet, blue, blue-green, green and yellow-green.

COMPLEMENTARY COLORS

Complementary colors are opposites on the color wheel; for example, red is opposite green. Complements can be used in many ways. Mixed together in equal amounts, complements become gray. For shadows, it is always better to mix a color with its complement rather than adding black.

A complementary color can also be used to make another color stand out; for instance, to make the color red stand out, place green next to it. This is used most frequently when working with flowers and nature. Because almost all stems and leaves are green and many flowers are red or pink, the flowers have a very natural way of standing out.

SHADES AND TINTS

A *shade* is a darker version of a color. A *tint*, on the other hand, is a lighter version. Shades and tints are the result of light and shadow.

Color Wheel

using color

Color can completely change the way something appears, and artwork can be altered by using different color combinations. This flower is drawn the same each time using three colors: Canary Yellow, Orange and Crimson Red. However, each time I drew it I changed the background color. The results surprised even me! This is a good way to experiment with colors. See what you can do using the color wheel as a guide. When looking around for things to draw, I think you will be surprised how color affects the overall look of objects, and how important it is in a successful piece of art.

Complementary Colors: Yellow vs. Violet

In this drawing, the yellow of the flower really pops out because violet is its complement.

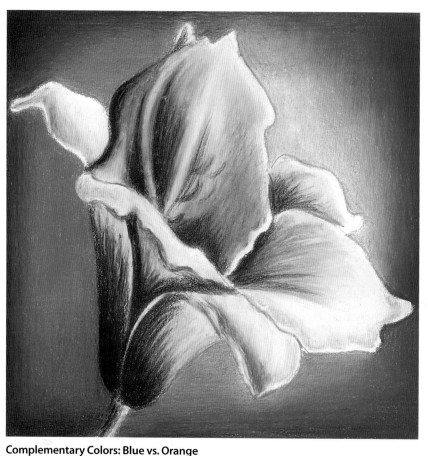

Complementary Colors: Blue vs. Orange

The orange tones of the flower are highlighted because of the blue background. Burnished background tones are a great way to provide stark contrast in your drawings.

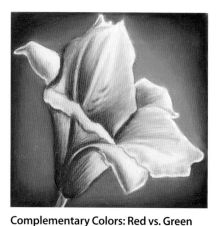

Complementary Colors: Red vs. Green

Notice how the red in this flower stands out, even though it is drawn just like the other two examples.

create contrast with color

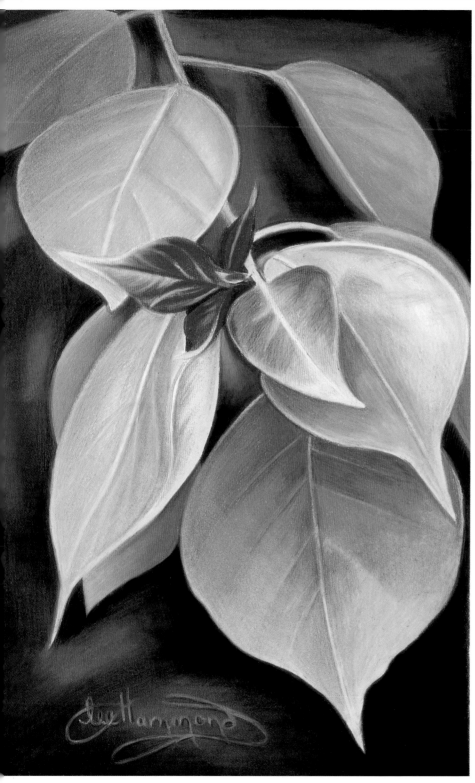

Complementary colors enhance one another. When you incorporate complements into your overall composition, you can achieve stunning results that pop from the page. Whether you're creating original artwork or working from photographs, always consult the color wheel to help you choose exciting, vivid color combinations.

Add Spice to Your Drawings With Complements

The green tones of the outer springtime leaves appear more beautiful because of the complementary red tones in the center.

Colors Used

Grass Green, Chartreuse, Lemon Yellow, Apple Green, Dark Green, Crimson Red, Pink, Black, White

five elements of shading

In order to create realistic drawings, you must be able to draw three-dimensional forms and understand how light affects those forms. There are five elements of shading that can be found in every three-dimensional shape. Practice creating these different tones. Once you've mastered them, you can draw just about anything.

1 Cast shadow

This is the darkest part of your drawing. It is underneath the sphere, where no light can reach.

2 Shadow edge

This is where the sphere curves and the rounded surface moves away from the light.

3 Halftone area

This is the true color of the sphere, unaffected by either shadows or strong light.

4 Reflected light

This is the light edge along the rim of the sphere that illustrates the roundness of the surface.

5 Full light

This is where the light is hitting the sphere at its strongest point.

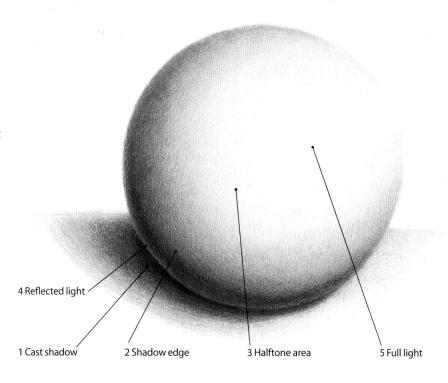

4 Reflected light

1 Cast shadow 2 Shadow edge 3 Halftone area 5 Full light

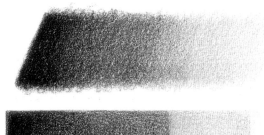

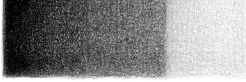

Dark Brown Terra Cotta Goldenrod Canary Yellow Cream

Value Key for Five Elements of Shading

The key to making things look multi-dimensional is contrast. This is what the tones of the sphere on this page look like when separated into a color key and placed in a value scale.

When drawing, transition colors from very dark to very light, allowing the tones to overlap and fade into each other. To create a sphere, you need to have at least five tones, hence the five elements of shading.

basic shapes

All subjects, no matter how complex, consist of underlying basic shapes. Learn to recognize these basic shapes, and you can draw anything by applying the five elements of shading!

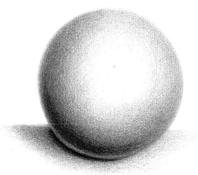

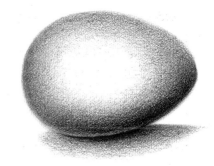

The sphere. This shape is seen in all rounded objects such as fruit, vegetables and even the parts of a person's face.

The egg. This shape is seen in birds, animals and the human head.

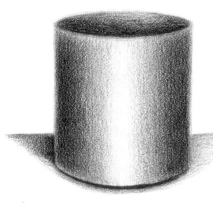

The cylinder. This shape is seen in arms, legs, trees and structures such as jars, glasses and cans.

The long cylinder. This shape can be seen in tree limbs, pipes, columns and other tubular structures.

The cone. This shape is seen in pointy objects such as party hats, building structures and vases.

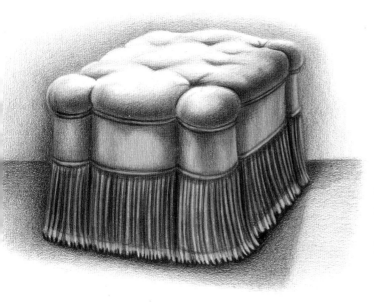

Basic Shapes in a Basic Object

Sometimes one object will be made up of multiple basic shapes. A cube, a sphere and a cylinder make up the basic structure of this footstool.

draw a sphere

MATERIALS

paper
Chamois Renewal by Strathmore

colors
Dark Umber, Poppy Red, Canary Yellow

Now it is time to practice applying what you've learned so far by drawing a sphere and an egg. This will help you commit the five elements of shading to memory. By practicing simple shapes such as these, drawing more difficult subjects later will be much easier.

Let's start with the sphere. Take your time, and make it look as good as possible. For more practice, try it again on your own, using different colors and different shades of paper.

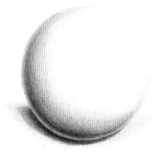
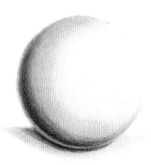

1 CREATE THE LINE DRAWING AND BEGIN THE SHADOWS

Tracing a round object, such as a glass or jar, or using a circle template or stencil, lightly draw a circle with a mechanical pencil and a very light touch.

Determine where the light is coming from. With Dark Umber and a very sharp point, apply the cast shadow opposite the light source, here, below the circle on the lower left, indicating the light is coming from the right side. With a very sharp point, apply the shadow edge, leaving a small edge of reflected light along the bottom of the circle. Be sure to apply the pencil lightly so the lines are not obvious. Use curved lines to replicate the shape and form of the sphere. Straight pencil lines would represent a flat object.

2 PLACE THE HALFTONES

With Poppy Red and a very sharp point, overlap the Dark Umber and gradually move out to create the halftone. Maintain the same light touch and curved lines as used in step 1. Allow your tones to gradually fade into the color of the paper. It is important not to have any choppiness.

Apply some of the Poppy Red to the cast shadow as well, allowing it to fade into the paper. Shadows become lighter as they move away from the object.

3 OVERLAP TO COMPLETE THE TONES

With Canary Yellow and a very sharp point, overlap the other colors and continue adding to the sphere. Allow the color of the paper to show in the full light area.

draw an egg

Now, let's apply the same techniques you used on the sphere to an egg.

MATERIALS

paper
Stonehenge

colors
Dark Umber, Chocolate

1 CREATE THE LINE DRAWING AND BEGIN THE SHADOWS

Lightly draw an egg shape with a mechanical pencil. When your shape is accurate, apply the cast shadow and shadow edge opposite the light source with Dark Umber and a very sharp point. Here, the light source is coming from the front, so the shadows are in the middle and along the sides.

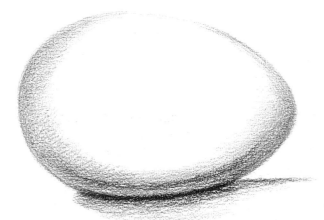

2 PLACE THE HALFTONES

With Chocolate and a sharp point, continue adding smooth tone to the egg, gradually fading it into the light.

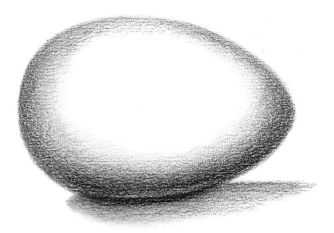

3 OVERLAP TO COMPLETE THE TONES

Continue adding layers of Chocolate to the egg and the cast shadow until it looks finished.

using a grid to draw from photos

Everything we draw can be done more accurately if we look at our subject matter as a group of interlocking, abstract shapes. Placing a grid over our reference photos can help us see things more objectively by dividing everything into small sections. The squares help us see our subject matter like a puzzle. You can even further your objectivity by turning the photo upside down.

There are two different ways to grid your reference photos. The first way is to have a color copy made of your photo. If the photo is small, enlarge it as well. Working from small photos is the biggest mistake most students make. The bigger the photo, the easier it is to work from.

Use a ruler to apply a one-inch or half-inch grid directly onto the copy with a permanent marker. Use the smaller grid if there is a lot of small detail in your photo. There is less room for error in the smaller box, so little things are captured more easily.

If you do not have access to a copier and your photo is large enough to work from, you can place a grid overlay on top of the photo. Make your own grid with a clear plastic report cover and a permanent marker, or have one printed from a computer on an acetate sheet. Then place the grid over the photo and work from that.

Once you place the grid over the photo, the image becomes a puzzle and each box contains shapes. Look at everything you want to draw as just a bunch of interlocking shapes.

To draw the photo, draw a grid on your drawing paper with your mechanical pencil. Draw the lines so light you can barely see them because they will need to be erased later. This grid should contain the same size and number of boxes as the one over the photo.

You can enlarge the size of your drawing by placing the smaller grid on your reference photo and making the squares larger on your drawing paper. For instance, if you use the half-inch grid on the photo and a one-inch grid on your paper, the image will double in size. Reduce the size of the drawing by reversing the process. As long as you are working in perfect square increments, the shapes within the boxes will be relative.

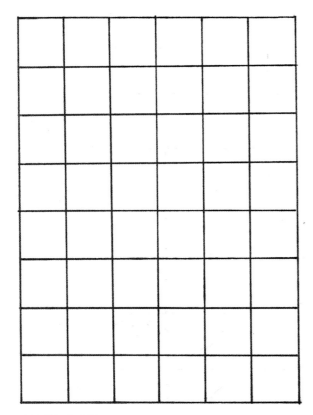

A Half-inch Grid

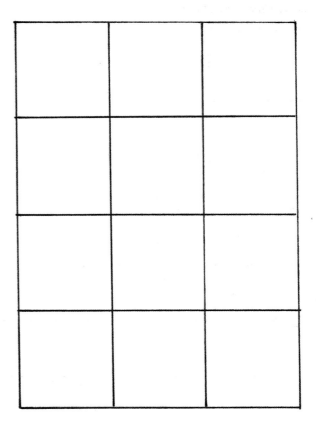

A One-inch Grid

create a line drawing with a grid

This exercise will show you how to draw from a graphed image. For now, don't worry about the colors in this photo; just concentrate on using the grid as a guide to capture the basic shapes in an accurate line drawing.

Remember, you can increase the size of your drawing by drawing larger squares on your paper. Keep this finished line drawing for the step-by-step exercise on pages 116–117.

step-by-step exercise on pages 116–117.

LEE'S LESSONS

For the exercises in this book, there is one exception to using the grid method: it cannot be done on suede board, because the mechanical pencil lines cannot be erased. Instead, use graphite transfer paper to transfer your line drawing to the suede board. See Lee's Lessons on page 99 for more details on transfer paper.

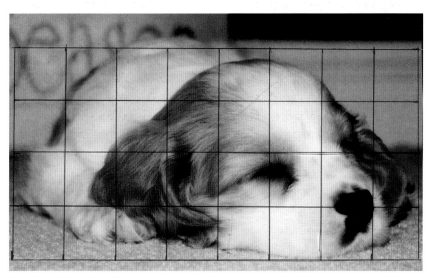

Create a Grid on Your Paper

On your drawing paper, lightly draw the same number of squares you see here.

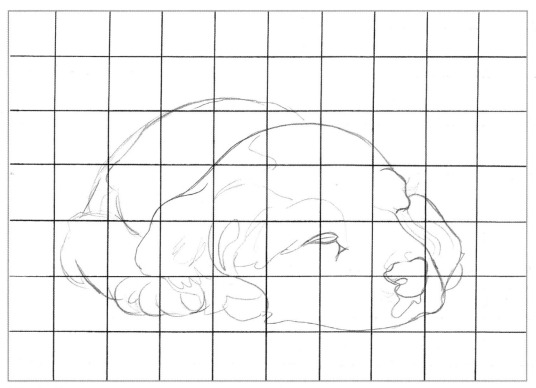

Fill in the Shapes

Working on one box at a time, capture the shapes you see in each box. Go slowly and be accurate. The entire outcome of the drawing hinges on this stage of the game.

MATERIALS

paper
Stonehenge

colors
Sand, Rosy Beige, Black Raspberry, Dark Brown

LEE'S LESSONS

Always start with the lightest color of an object then build the darker colors on top.

After practicing the sphere and the egg, you can now advance to a more complicated object, such as this teapot. The overall shape is basically a sphere, and the handle, top and spout add unique dimensions.

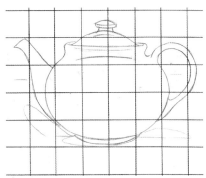

1 CREATE THE LINE DRAWING

Create this line drawing using the grid method. Lightly sketch the shapes of the teapot in each square using your mechanical pencil. Erase the grid and any mistakes with a kneaded eraser until your drawing is accurate.

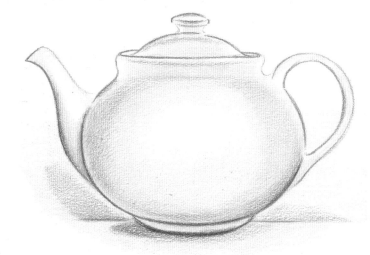

2 BEGIN THE SHADOWS AND BUILD THE HALFTONES

With Sand, fill in the main color of the teapot, leaving the white of the paper exposed for the highlight areas. Apply Dark Brown to the outside edges of the teapot, making sure to vary them in line width and darkness.

The light source is coming directly from the front, so the shadows are cast along the sides and behind the teapot. Use Dark Brown to add the cast shadow under the teapot and on the wall behind it, then begin building the halftones on the teapot, fading the tones toward the full-light area. The basic form of the teapot is now complete. You can see the reflected light along the rim and bottom of the teapot.

3 OVERLAP TO FINISH THE TONES AND SHADOWS

Overlap the shadow areas with Dark Brown and then Rosy Beige. Continue fading into the lighter areas, making sure your colors look even and gradual.

Finish the teapot by adding Black Raspberry to the contours to give the pot a warm hue. Maintain a very sharp point and overlap the existing colors. Add a small amount of this color into the shadow areas behind and below the teapot.

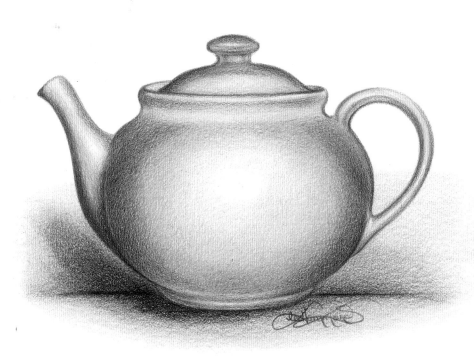

32

capture shapes with segment drawing

Just like using a grid, segment drawing breaks down large shapes into smaller, more manageable increments. It follows the same principles, but deals with only one large square instead of a grid of many squares. In this method, you crop very closely into a reference photo and concentrate on only shapes and lines.

MATERIALS

paper
Stonehenge
Black construction

colors
Peach, Dark Brown, Pink, Black

other
Craft knife

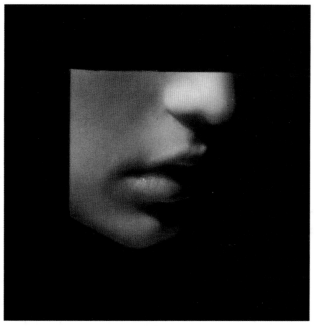

1 CREATE THE VIEWFINDER
Cut a 2" (5cm) square out of a piece of black construction paper with a craft knife.

2 PLACE THE FRAME OVER A PHOTO
Place the viewfinder over your photo so only a small portion of the image is visible. This changes the photo into a composition of abstract shapes.

LEE'S LESSONS

When using a mechanical pencil to create your line drawing, it is important to draw lightly. As you start to apply the colored pencil, lighten the lines with a kneaded eraser. Be cautious when applying light colors over graphite, because the graphite may be difficult to disguise.

3 CREATE THE LINE DRAWING
Draw a square on your drawing paper the same size as the viewfinder. With your mechanical pencil, freehand the shapes of your photo as accurately as possible. Use the outside of the square as a guide, visualizing how far from the edge the shapes are.

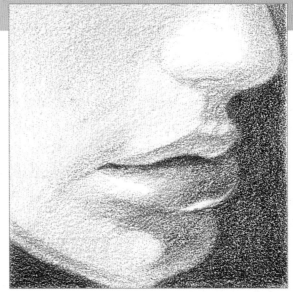

4 ADD THE BASIC SHADOWS OF THE SUBJECT

Add shadows to the face with Dark Brown, using a very sharp pencil point. Note that the strong light source is coming from the left, forming distinct shapes and edges of the shadows on the lower part and right side of the face.

5 FILL IN THE BACKGROUND AND MIDDLE VALUES

Fill in the background with Black to form the edges of the face, eliminating the outlines. Create the skin tone with a light layer of Peach. Vary the tone depending on the strength or weakness of the light source reflection, and deepen the shadows with Dark Brown. The reflection is strong under and alongside the nose, so use fewer layers of color there. Add a bit of Pink where the light directly hits the lip.

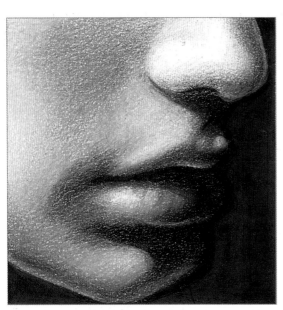

6 CONTINUE LAYERING AND FINISH DETAILS

Continue layering the color with a very sharp pencil point, keeping the tones as even and smooth as possible. Once the Peach has filled in to create a good skin tone, add more Dark Brown to the shadow areas to intensify the look of reflected light. It is most obvious along the edges of the face, along the edge of the tip of the nose and along the lips. Strengthen the dark tones with Black to create greater contrast. Be patient; this technique takes time to create smooth tones.

Viewfinders Can Be Any Size or Shape

Use your imagination to create viewfinders in any size and shape. The smaller the opening, the more you will be able to divide your photo into unrecognizable shapes, thus making it easier to draw.

Enlarge a smaller project. For instance, the face in this exercise could be blown up and drawn on a much larger scale. It would make an awesome drawing for the wall.

using your viewfinder

To gain a lot of drawing practice without the feeling of being overwhelmed by large, finished projects, begin a segment-drawing notebook. This is a page taken from one of mine.

Create a viewfinder with a two-inch opening. Go through magazine pictures to find interesting subjects to draw. Select pictures that will give you a variety of challenges and learning experiences.

Draw a border using a Black Prismacolor pencil around each drawing for a cleaner-looking presentation.

Start your own segment-drawing notebook as soon as possible and try to draw at least one image a day. You can do it. They are small exercises and don't take very long, but the experience you gain is huge!

THINGS TO REMEMBER

- All colored pencil drawings begin with layering.
- If you begin with layering, you can always go back and burnish an area if it doesn't turn out the way you want.
- When practicing burnishing, use pencils with a duller point to balance out the heavy pressure of application.
- Regardless of the technique you use, the pressure you apply is most important.
- For shadows, it is always better to mix a color with its complement than to add black.
- A shade is a darker version of a color. A tint is a lighter version.
- The five elements of shading can be found in every three-dimensional shape.
- To create a sphere, you need to have a least five tones.
- Enlarge a reference photo if it is small. This makes it easier to work with.

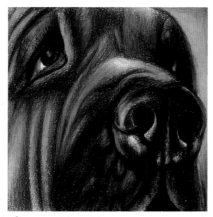

Practice drawing the unique contours of animals with segment drawing.

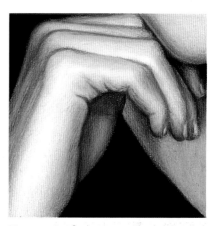

Use your viewfinder to practice drawing the complex shapes of hands.

This interesting study of texture is the tail of a betta fish.

The human anatomy is a wonderful study of form and tones.

Master the facial features by practicing them individually.

A section of a flower can provide excellent practice with color.

Round & Cylindrical Objects

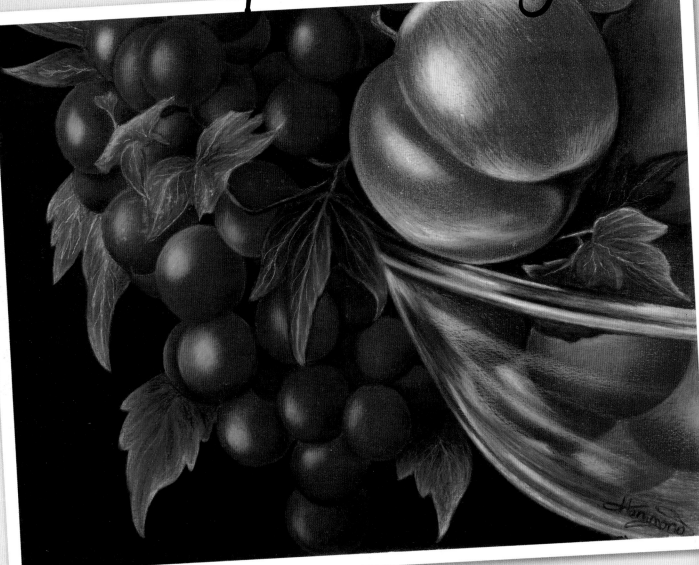

Segment Drawing of a Fruit Bowl
#1008 Ivory mat board
12" × 12" (30cm × 30cm)

Understanding the sphere and the five elements of shading is vital for beginning artists. It is the basis for so many different types of subjects—simply look around you. Think of this chapter as the flagship of your drawing instruction. With practice, you will be able to combine all of the basic shapes into any object you can imagine.

Use a Viewfinder to Practice Round Objects

This segment drawing is full of round objects. It was created using the viewfinder method by isolating a very small section of a photograph of a fruit bowl.

Colors Used

Canary Yellow, Yellow Orange, Lime-peel, Apple Green, Grass Green, Dark Green, Poppy Red, Crimson Red, Dark Purple, Tuscan Red, Black, White

Grapes have a shiny skin that reflects light in a unique way. Before you begin to draw, study how the light hits your subject to locate all the shadows and edges of your drawing. Notice how the individual edge of each grape varies in the bunch. Where two grapes overlap, there is a light edge of reflected light. Where the grapes contrast against the white background, there is a darker edge. It is always important to figure out the undertone, or lightest color of the drawing, before you begin.

MATERIALS

paper
Stonehenge

colors
Peach, Carmine Red, Black Raspberry, White

1 CREATE THE LINE DRAWING

Sketch or trace a circle with a mechanical pencil. Lightly place in the Peach undertone, allowing the white of the paper to remain in the highlight areas. Lightly apply Black Raspberry along the edges of the grape, and create the inside shadow edges.

2 DEEPEN THE TONES

Add some Carmine Red to the shadow edges and continue to deepen the areas of Black Raspberry with more of the same. At this stage of the drawing, the colors are still layered.

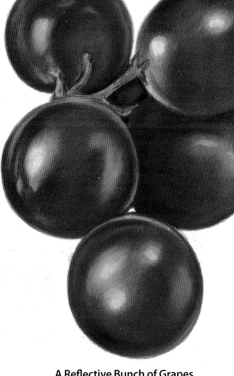

A Reflective Bunch of Grapes
Grapes are round, shiny and reflect a lot of light. Study your subjects for light and dark edges before you begin to draw.

3 BURNISH THE TONES TOGETHER

Burnish the colors to give the grape a shiny appearance. With Carmine Red, apply pressure and overlap the darker areas. Once the colors look smooth, take the White pencil and burnish into the highlight areas. If you aren't happy with the way it looks, you can go back and forth with the colors, adding more lights or darks. Whenever you add a color to the drawing, make sure to burnish the colors together with the lighter color and blend them together.

red apple with highlights

MATERIALS

paper
Stonehenge

colors
Canary Yellow, Scarlet Lake, Tuscan Red, Dark Brown, Limepeel, Black, White

An apple study is excellent practice for drawing a round, sphere-like subject. Because it has a waxy, shiny surface, the lighting of an apple is very distinct. The glare reflecting off the apple is usually dramatic.

When drawing colorful subjects, add the colors in layers, beginning with the lightest. I started this apple by drawing in the yellow undertones first. If you look at the finished example, you can see how important the yellow is because it shines through the other colors.

1 SKETCH THE APPLE AND APPLY THE BASE COLOR

Lightly draw the shape of the apple with a mechanical pencil. With Canary Yellow and firm pressure, fill in the entire apple, excluding the highlight areas. These spots should be left as the white of the paper. With Scarlet Lake, begin adding red tones to the shadow areas of the apple. Be sure to use curved pencil lines to help create the illusion of roundness. The apple skin has a lot of streaks, and these curved lines help create them. Use Tuscan Red to begin the stem and the shadow area around it.

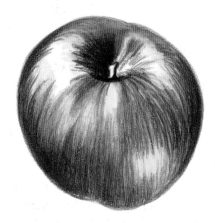

2 BUILD THE MIDTONES

Build the red tones with Scarlet Lake. The color is deeper toward the bottom of the apple and along the sides. Add some Tuscan Red to deepen the shadow areas. (Refer to the finished drawing for placement.) Again, the curved pencil lines are essential. While this drawing is utilizing the burnished technique, the streaks of the pencils' lines should still be seen.

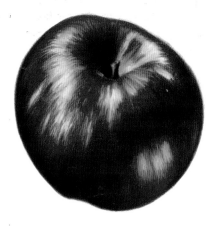

3 FINISH THE DRAWING

Continue building the tones using a firm pressure until the colors become deep and rich. Be sure to allow the yellow to show through in areas, and the red to streak in curved lines. For deep red tones, use Tuscan Red and a thin layer of Black on the shadowed side of the apple. Burnish the Black with Tuscan Red to soften the color.

Notice the tiny edge of light around the lower left side of the apple. Do not color the deep tones all the way to the edge. This will produce a rim of reflected light and help create the illusion of dimension.

To finish the drawing, burnish White into the highlight areas, overlapping the red and yellow tones to create a reflection of light. Complete the stem by placing Dark Brown on the right side and Limepeel to the left. To create depth in the stem, add a touch of Black along the top and sides, and to the rear shadowed area. To complete the stem, add a tiny bit of Limepeel on the apple skin behind the stem on the right side.

pear with a cast shadow

This exercise is drawn with many of the same colors as the apple project on the previous page. However, the shape has changed and the lighting is different, casting an obvious cast shadow.

MATERIALS

paper
Stonehenge

colors
Canary Yellow, Orange, Scarlet Lake, Tuscan Red, Dark Brown, Limepeel, White

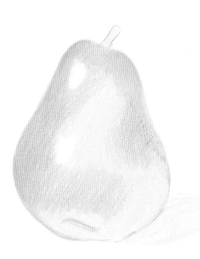

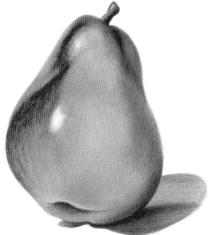

1 SKETCH THE PEAR AND PLACE THE UNDERTONES

Lightly draw the shape of the pear using a mechanical pencil. Base in the entire surface of the pear with Canary Yellow, except for the two highlight areas, which should be left as the white of the paper. Use firm pressure to burnish the entire area. Create the shape of the cast shadow under the pear on the right side.

With Orange, lightly layer some color along the left and right sides of the pear. Apply a small amount of Limepeel to the right side as well.

2 DEEPEN THE TONES AND CREATE THE CAST SHADOW

Continue building the Orange color to deepen the hue, still leaving the white areas alone. Leave some yellow showing along the bottom of the pear and along the edge of the recessed area on the pear's base. Like the sphere exercise on page 28, this will form the rim of reflected light to make the pear appear more rounded.

With Dark Brown, create the dark side of the stem. Also apply some of the Dark Brown to the recessed area on the bottom.

Add both Dark Brown and Limepeel to create the cast shadow, noting how it is divided in half with the two colors.

3 FINISH THE DRAWING

To finish the pear, continue the layers of color until the 3-D look is created. Apply Scarlet Lake to the left side of the pear to create a beautiful red glow and the illusion of the shape of the pear. Make sure to curve your pencil strokes to follow the contours of the pear.

Use Tuscan Red along the bottom of the left side to create the shadow area, and also add some of it into the cast shadow. Also apply the Tuscan Red to the upper left side of the pear and to the stem to complete it.

With White, burnish the highlight areas to make them appear shiny.

pumpkin and apples

MATERIALS

paper
#1008 Ivory mat board

colors
Canary Yellow, Orange, Pumpkin Orange, Scarlet Lake, Dark Brown, Aquamarine, Black, White

Now let's go to a more complicated composition using many of the same colors used in the grape exercise on page 37. The colors used in the pumpkin and apples are deep and rich because of the light source and deep shadows, and are intensified by the use of complementary colors in the background.

Sketch out the shapes of the pumpkin and apples, using my drawing as a guide. Use a mechanical pencil so you can make corrections if you need to. Don't worry if your drawing is not exactly like mine. With still-life objects such as fruit, perfection isn't that important. It is the technique of applying colored pencil that is the focus.

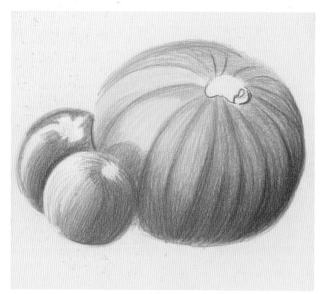

1 APPLY THE UNDERTONE AND INITIAL LAYERS OF COLOR

Create this drawing with many, many layers of color. Once you have the outline drawn, apply the first layer of colors to the pumpkin and apples. As we did in the previous exercises, apply the Canary Yellow as the undertone. Because of the deep shadows of this piece, the yellow is more evident on the left side.

After the Canary Yellow is applied, add Pumpkin Orange to the right side of the pumpkin. Use this color to create the ridges of the pumpkin skin. Add some of this color to the right side of the apples, too.

With Dark Brown, create the cast shadow of the apple onto the left side of the pumpkin in the yellow area. Add the Dark Brown to the lower area of the pumpkin to create the shadow area. This makes the pumpkin appear rounded. Apply Scarlet Lake to the right sides of the apples.

2 DRAW THE BACKGROUND AND STEMS

Use Aquamarine for the background color behind the fruit. To create the dark color below, first layer some Dark Brown, and then layer Black on top of it. Allow the Dark Brown to show around the edges of the shadow.

Create the stems of the fruit with Dark Brown. Use the Dark Brown to create the cast shadow that separates the two apples, and to deepen the shadow area on the pumpkin.

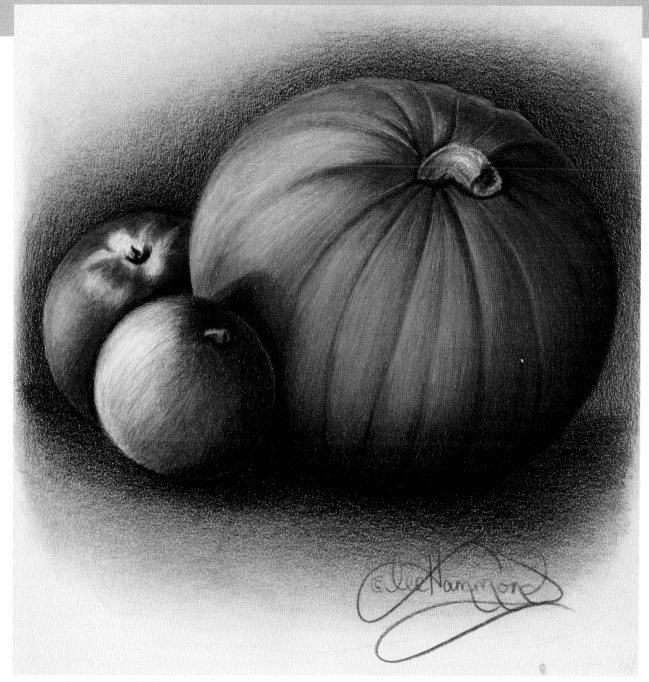

3 CONTINUE TO BUILD COLORS AND FINISH THE BACKGROUND

Finishing the drawing is really just a matter of doing more of the same. The colors continue to build up with every layer, until it becomes deep and rich.

Be sure to pay attention to reflected light, which is extremely important when drawing rounded objects. Reflected light is seen anytime there is an edge or rim. You can see it along the edges of the apples, and along the upper edge of the pumpkin. But it is also seen along every ridge of the pumpkin, which makes those areas seem to protrude. Use Orange in these edges to make the reflected light more obvious. Burnish the Orange in the front of the pumpkin to make the color shine. Burnish Canary Yellow into the apples to make them shiny, too.

When the colors of the fruit are nice and deep, finish the drawing by detailing the stems with Dark Brown, Black and White. Again, make sure to include reflected light around the upper edges.

Deepen the background with more Aquamarine, and layer Black directly behind the fruit for more depth of tone.

Add some of the Scarlet Lake to the ground in front. You can see how the shadow area becomes lighter as it moves away from the fruit. Make the shadows more intense under the fruit by layering Black on top.

practice drawing rounded objects

Now that you've completed a few step-by-step exercises, try some drawings on your own using your acetate grid. To become proficient in colored pencil drawing, it is important to learn the patience required for layering color. These illustrations combine many of the drawing elements we reviewed on the previous pages. The overall shape is still a sphere. Follow the shapes of light and shadow to recreate common objects such as these lemons, pear and apple. Have fun and remember that good drawing takes time!

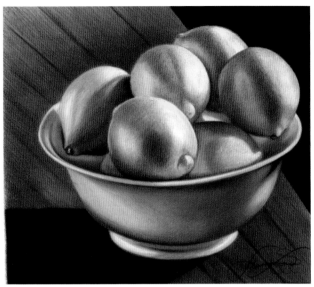

To Layer or Not to Layer

Sometimes you may not decide until the final stages of a drawing whether it will be layered or burnished. I mostly used the layering approach to draw this bowl of lemons. During the final stages of the drawing, I decided to burnish the background and the bowl's cast shadow with Black to intensify the piece.

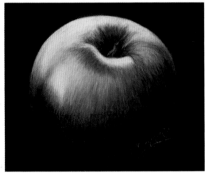

Change the Colors of a Common Object

It is amazing to me how brilliant and realistic colored pencil can be. Here is another way to use the skills you just learned. Simply change the colors, and you can change the entire look! A simple apple can make a very dramatic drawing.

Colors Used
Lemon Yellow, Canary Yellow, Sunburst Yellow, Orange, Terra Cotta, Dark Brown, Sienna Brown, Clay Rose, Lavender, Cool Grey 50%, Black, White

Practice Makes Perfect

Once you have mastered the basic techniques of drawing with colored pencil, you can create more complicated drawings. This drawing shows what is possible when you know how to draw a pear.

ellipses

So what happens when round objects no longer look perfectly round? If you look at a cylinder, you know that if you viewed it from the top it would look like a circle. But, when viewed from the side, you see a circle in perspective. This perspective represents distance and changes a circle into an ellipse.

Look at the wagon wheel below. If it was still on the wagon it would look like a perfect circle. But the wheel is lying on its side, so we see it in perspective. Receding lines are made shorter than they are in reality to create the illusion of depth. This is a phenomenon called *foreshortening*. It is what turns a circle into an ellipse.

Standard Circle

This is a circle viewed straight on.

Vertical Ellipse

When viewed from a different angle, perhaps closer to a side view, the shape appears thinner than the full circle. This is called an ellipse, which by definition is a circle in perspective.

Horizontal Ellipse

This is a circle viewed from above. Instead of a thick appearance, like the vertical ellipse, this ellipse seems flattened out.

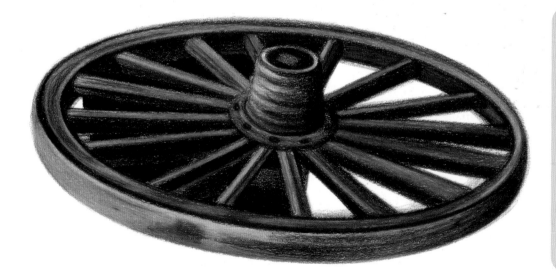

LEE'S LESSONS

When drawing elliptical objects, you should be able to fold each ellipse in half in either direction, with all parts matching. This is called the equal quarters rule.

Perspective Creates Ellipses

Circles viewed from the side, such as this wagon wheel, are no longer perfect circles. Seen in perspective, the circle appears flattened and stretched out. The degree of perspective of an ellipse depends on the angle in which it is viewed.

everyday cylinders

Drawing cylinders is all about keen observation and understanding your drawing subject's lighting, perspective and texture. Flower stems, tubes, snakes and trees all have the same cylindrical elements to capture.

The top portion of a cylindrical object, viewed in any perspective, is always in the shape of an ellipse. It is important to draw these accurately because the entire perspective of the object hinges on it.

Study these everyday objects, and see how each one of them is made up of both a cylinder and an ellipse.

Ellipses in Perspective

This spool of thread is drawn from a bird's-eye view, which changes the perspective dramatically. The top of the spool appears much larger than the bottom, even though in reality they are identical in size. Keep in mind that ellipses within a drawing can change depending on your point of view.

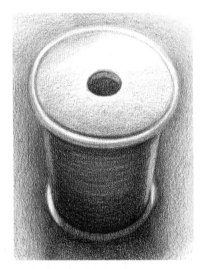

Ellipses in Light

These candles are long cylinders. Because of the vantage point and the irregular tops, the ellipses are not as noticeable. Observe how the five elements of shading differ for each candle. The candle on the left is set against a very dark background making the edges appear very light. The candle on the right is set against a light background, making the right side of the candle appear dark. It is important to fully understand the lighting of your subject before you begin to draw.

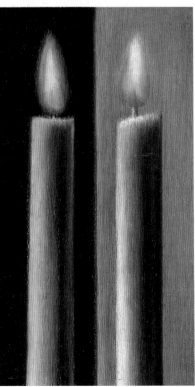

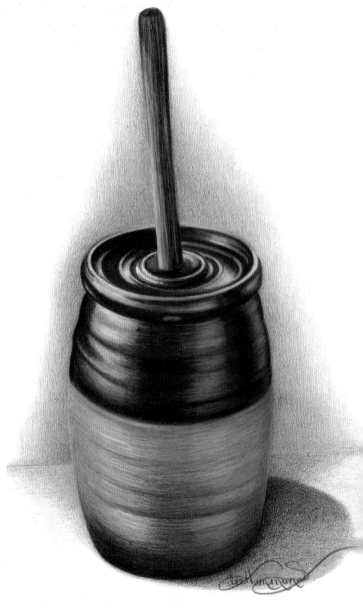

Observe the Cylinders and Ellipses in Everyday Objects

Look around your home and observe just how many cylindrical household items fill your everyday life, such as bottles, vases, jars, candles and glasses. This antique butter churn is a complex collection of textures, cylinders and ellipses. Notice the many ellipses along the top of the lid of this churn. When drawing, alter your edges a little at a time until your ellipses appear correct.

Colors Used
Dark Brown, Black Raspberry, Peach, Cloud Blue, Mineral Orange, Black, White

textured cylinder

A tree limb or trunk is also a cylinder, just with a lot of texture. Use this exercise to practice drawing the cylindrical shape of a tree. Even though the surface is irregular and textured, the basic form is still a cylinder with the effects of light and dark creating the roundness.

MATERIALS

paper
Stonehenge

colors
Sienna Brown, Dark Umber, Black, White

1 SKETCH THE TRUNK AND APPLY THE LIGHTEST TONES

Sketch the shape of the trunk and limbs with a mechanical pencil. Don't forget to include the large tree knots. With heavy, vertical pencil lines, apply the texture of the tree bark. Start with Sienna Brown first, and then layer on Dark Umber.

LEE'S LESSONS

The edges of an ellipse should always be curved, with no flat areas. The ends of an ellipse, at the tightest curves, should never appear pointed.

2 BURNISH AND DEEPEN THE TONES

Burnish over the colors with White to make them blend together. Reapply the Dark Umber to deepen the tones. Use Black to intensify the dark areas of the tree bark, giving it the illusion of heavy texture.

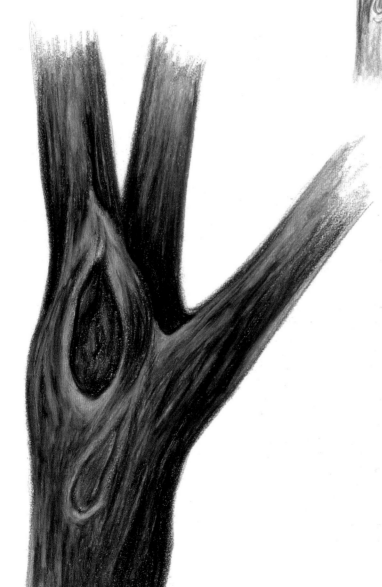

MATERIALS

paper
Stonehenge

colors
Sky Blue Light, Denim Blue, Blue Violet Lake, Clay Rose, Seashell Pink, Greyed Lavender, Black, White

LEE'S LESSONS

When an ellipse is drawn incorrectly, your brain screams that something is wrong. Here are three tips to drawing ellipses correctly:

1 Remember, you are drawing a circular shape; there should be no flat spots or pointy areas in the smallest area where the ellipse curves.

2 Visualize all sides of the elliptical object and draw the complete ellipse before shading. Try to see through it.

3 Remember, you should be able to fold your ellipse in half, with all sides matching.

There is a mathematical way to produce an ellipse based on the degree of pitch and its angles. But you don't need a formula to tell you when an ellipse is off. This drawing looks complicated, but it really isn't. Follow along, and you can see for yourself.

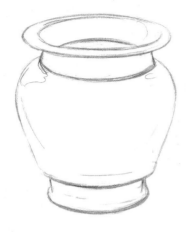

1 CREATE AN ACCURATE LINE DRAWING

Sketch the vase's basic shape with a mechanical pencil. When drawing any object, having accuracy from the beginning is essential. It allows you the freedom of blending and shading without having to make structural changes. Altering the shape is very difficult after the tones have been added.

2 OUTLINE THE ELLIPSES

The ellipses encompass the surface of the vase, all the way around. Drawing through the object to complete the ellipses helps the pot look symmetrical and realistic. You can cover your lines when you add color in the next steps, drawing through will help you visualize your shapes.

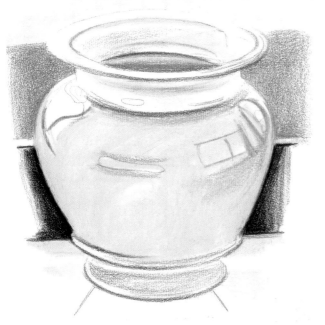

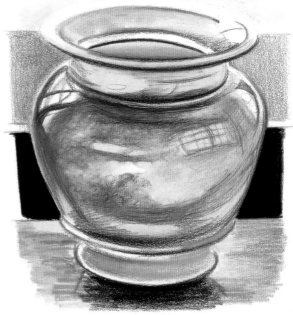

3 DEFINE THE HIGHLIGHTS AND BACKGROUND

This pot is full of reflections and highlights. Lightly outline the shapes of the reflections of windows using Blue Violet Lake. Using the same color, redraw the elliptical lines in the upper rim of the pot, and below it to show the curves.

Burnish in the lightest undertone of the pot first using Sky Blue Light, leaving the bright highlight areas exposed as the white of the paper.

With Clay Rose, fill in the inside area of the pot. Use enough pressure to fill in the paper completely with color. With Seashell Pink, fill in the base of the pot, the inside area of the upper rim and along the neck of the pot as seen in the illustration. This begins the look of reflective color.

Move to the background. Use a ruler to divide the background into three sections. The tri-color background gives the drawing more contrasts and interest than a solid color would provide. By placing these colors behind the subject, the edges of the pot are defined. Burnish in Sky Blue Light in the top section. (Since the edge of the pot is white, this background color creates the upper edge.) Move on to the middle section with Clay Rose. Use light layering and a very sharp point to create an even tone to give the drawing some textural difference. Leave a small white strip below the Clay Rose. Next, lightly layer Black around the edge of the pot. Be careful not to lose the nice, round, symmetrical shape. Finally, layer some more Sky Blue Light in the lower section.

4 CONTINUE BURNISHING

Burnish more Sky Blue Light inside the rim and above the pot to make it deeper in tone. Use Blue Violet Lake to add more color to the inside rim and body of the pot. On the pot, use a circular motion with the flat of the pencil lead, not the point. This will give the illusion of the speckling seen in the glaze. Look closely at the illustration and you can see where I used these circular strokes, and where the pencil lines are just drawn in.

Switch to Denim Blue, and build the dark tones on the pot. Intensify the color on the left side of the pot and the inside edge, being careful to create the window patterns in the highlight areas. Use this color to add the shadow edges to build the form and roundness of the pot.

Burnish the areas of Seashell Pink to make them more filled in. Burnish the black of the background to make it solid. Add Black under the pot to create a shadow. Deepen the colors of the tabletop, burnishing with firm, horizontal strokes of Greyed Lavender, Clay Rose and Sky Blue Light, allowing the colors to overlap one another. This gives the look of a shiny, reflective surface.

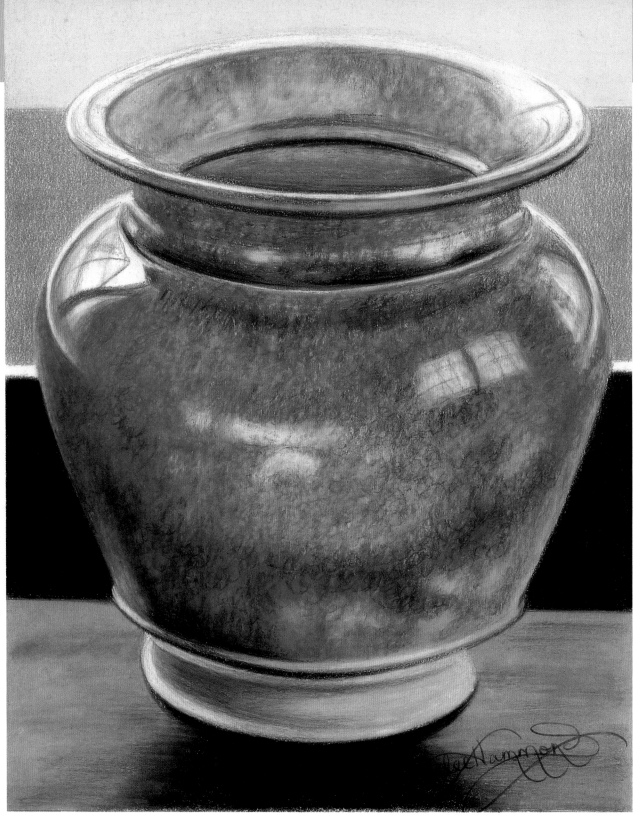

5 FINISH THE DRAWING

Continue burnishing the colors. This process takes some time, but is more than worth the work involved. Study the example carefully, and you can see where I used the circular strokes, inside and out, to create the look of the glaze. To make the highlights look bright and shiny, burnish over them with White.

Deepen the shadows by adding a small amount of Black. You can see it along the neck of the pot and along the left side. It is also seen in the edges of the rims. Add a bit of Black to the surface of the pot as well, using small, circular strokes.

Continue burnishing the tabletop, alternating colors to make it look streaky.

THINGS TO REMEMBER

- When drawing colorful subjects, it is important to add the colors in layers, beginning with the lightest.

- Figure out the undertone, or lightest color of the drawing, before you begin.

- Using a circular motion with the flat of the pencil lead will give you the illusion of speckling like that found in pottery glazes.

- Look for the five elements of shading, particularly reflected light, when drawing rounded and spherical objects.

- Foreshortening is when the shape of an object appears distorted because of the angle in which it is being viewed.

- An ellipse is a circle in perspective.

- Your eyes will tell you when an ellipse is not symmetrical.

- An ellipse can always be divided into four equal parts. You should be able to fold it in half either direction with all parts matching.

- The edges of an ellipse should always be curved, with no flat areas. The ends of an ellipse, at the tightest curves, should never appear pointed.

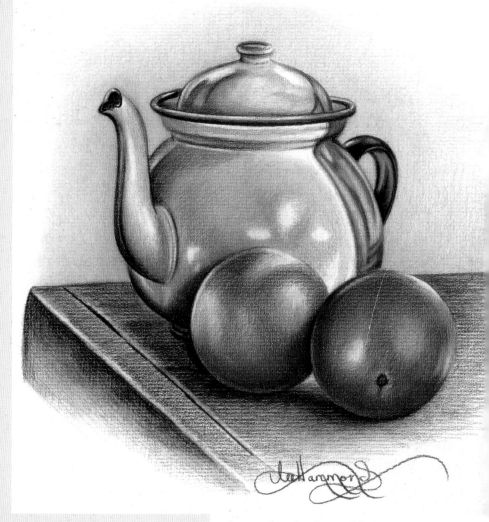

Create a Complex Composition

This still life contains everything we have learned so far about spheres, the five elements of shading, cylinders and ellipses. See what you can find to create a composition with all these elements.

4 Rectangular Objects & Perspective

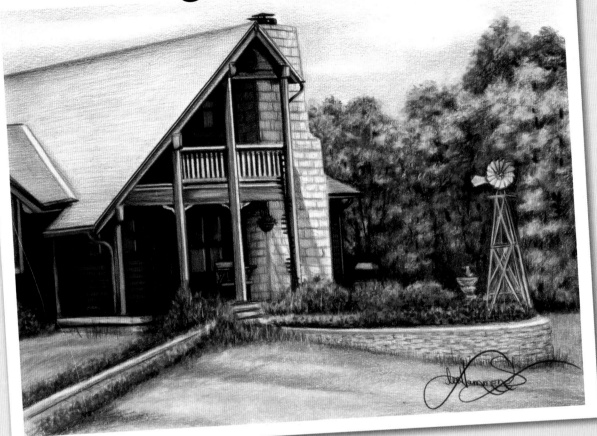

Many ordinary, everyday objects are angular in shape and made up of squares and rectangles. If it has a flat surface and a corner, chances are its basic shape is a cube.

You learned in the previous chapters how to use tone and gradual shading to create the soft curves of a rounded object. The rules really change when you are dealing with rectangular objects. Instead of soft edges you have hard edges, where two sides come together. The changes in tone are more abrupt, because each side will take the light differently, giving them different tones.

Every time you have a hard edge, you will also have reflected light. Always remember, everything with an edge, lip or rim has reflected light along it. Look around for the cube shape in everyday household items. Tables, chairs, books and stairs all share the same basic shape as their foundation. Even a soft, stuffed chair is geometric in shape.

Our Country Home
Stonehenge paper
11" × 14" (28cm × 36cm)

More Than Just Your Point of View

Without understanding the rules of perspective, it would be impossible to create a drawing of your home, like I did here. I've seen many a drawing or painting fall short because of inaccurate perspective.

Study and practice the exercises in this chapter and you will acquire a better eye for perspective. It will help you see all the angles and slants that are so important in your drawings.

Colors Used

Dark Brown, Sienna Brown, Dark Umber, Mineral Orange, Peach, Tuscan Red, Sand, Cool Grey 50%, Crimson Red, Pink, Cloud Blue, True Blue, Grass Green, Apple Green, Dark Green, Canary Yellow, Chartreuse, Black, White

perspective basics

Entire books have been written about perspective. Basically, images change depending on the vantage point from which you view them. Areas that are closer seem much larger, while areas farther away seem to shrink. In realistic drawing, you must always remember this. Your artwork reflects where you are in relation to your subject matter.

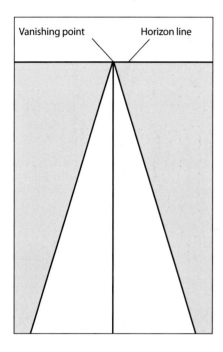

Vanishing point Horizon line

One-Point Perspective

A train track or road is large up front and converges into a point in the distance. When everything converges at one point out on the horizon it represents *one-point perspective*. That point is called the *vanishing point*. The vanishing point rests on the *horizon line*. This horizon line represents your own eye level when looking straight ahead.

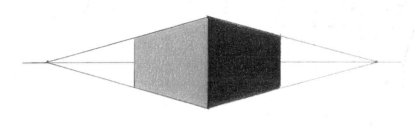

Two-Point Perspective at Eye Level

In this example, the cube's horizon line falls right in the middle of the horizon line. You are viewing the cube straight on and are standing on the same level as it.

Get Out the Ruler!

When drawing rectangular objects, make sure that all vertical lines are perfectly straight and parallel to the edges of the paper. This will help ensure accurate perspective.

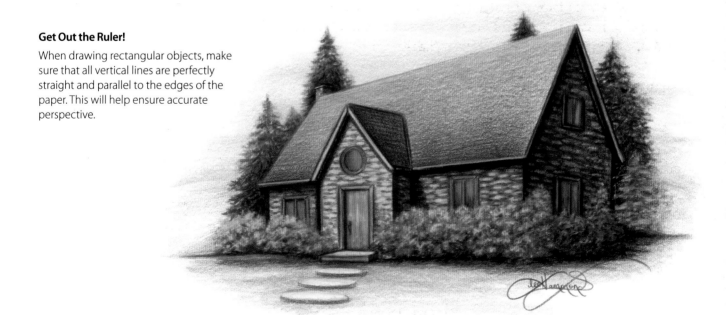

perspective and vantage point

Perspective can be daunting to the beginning artist, because it appears mathematical and complicated. Like anything else, a basic understanding and some practice go a long way. When viewing art, the first step is locating the horizon to determine your vantage point, or the angle at which you are viewing an object (e.g., straight on, above or below).

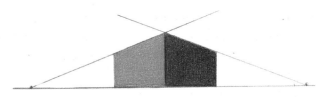

Two-Point Perspective Above Eye Level

The entire cube is above the horizon line, which means you are viewing it from a lower vantage point. You have to look up at the cube. If this were a building, you would be at the bottom of a slight hill, looking up the street. The light is coming from the left, making the side on the right appear darker.

An Example of Inaccurate Perspective

This birdhouse is nothing but a little rectangular box in two-point perspective. Because it was made by a child, the surfaces don't fit together well, and it is a bit out of plumb. I decided not to fix this in my drawing because I like the innocence of its construction and the story it tells. Even though the perspective is off, I love the pastel colors of the wood against the background and the leaves in the trees.

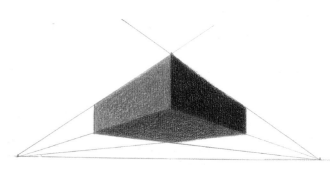

Above the Horizon Line, or Worm's-Eye View

This cube is elevated, floating above the horizon line. It is much higher than eye level and you see its bottom. Can you see how the lines converge at the horizon line at the same points?

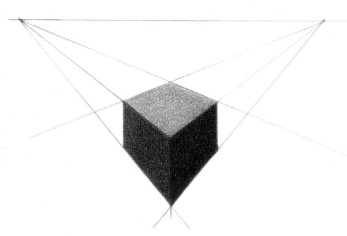

Below the Horizon Line, or Bird's-Eye View

This time, we are much higher than the cube and the horizon line, looking down on it.

everyday rectangular objects

Once you begin to look, you'll see cubes all over. While all these subjects are completely different in the way they look and the function they perform, each one is made from the same basic underlying shapes. Practice drawing rectangular objects in perspective, and it will soon become second nature to you!

A Stack of Books in Perspective

Study photos of rectangular objects, like these books, and analyze the rules of perspective. Basic underlying shapes are the same. See how the rules of perspective apply to them? They seem to get smaller toward the back. If you drew lines continuing out from the sides, those lines would converge at a common point in the horizon, creating a V shape.

A good way to better your understanding of perspective is to study magazine photos of houses and furniture. Take a ruler, carry the lines out from the edges and see where the lines meet with the horizon.

Even Your Favorite Chair Is a Cube

This comfy chair is nothing more than a complex cube. Each cushion and arm rest is rectangular, as is the pillow. Look for rectangular things in your own house to draw to give you practice with perspective.

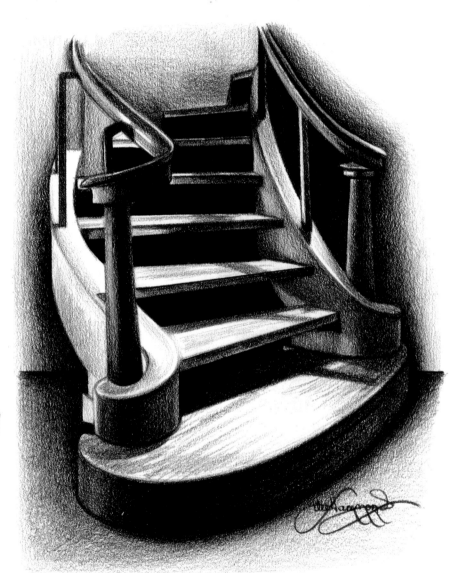

Draw Stairs as Cubes

This staircase is made up of cubes (the stairs) and two cylinders (the columns). Each stair has four flat surfaces that make up its rectangular shape. Because of the perspective, you view each stair from a different height and angle. The stairs seem to become smaller as they ascend, and you cannot see the top surface of the upper stairs. This is an illusion that can be very confusing when trying to draw. Our brains know that each stair is the same size, but our eyes see it differently. That is why understanding perspective is so important.

demonstration
draw a room

MATERIALS

paper
Stonehenge

color
Dark Umber

When learning perspective, start with a simple one-point perspective drawing, such as this living room scene. In the working drawing of step 1, notice how everything in the room meets at a single point in the center of the drawing. The arms of the couch, the edges of the coffee table and even the books underneath lead to this one point.

Each vertical line in the drawing—such as the legs of the table, the sides of the couch and the edges of the cups—are all perfectly vertical with no slants.

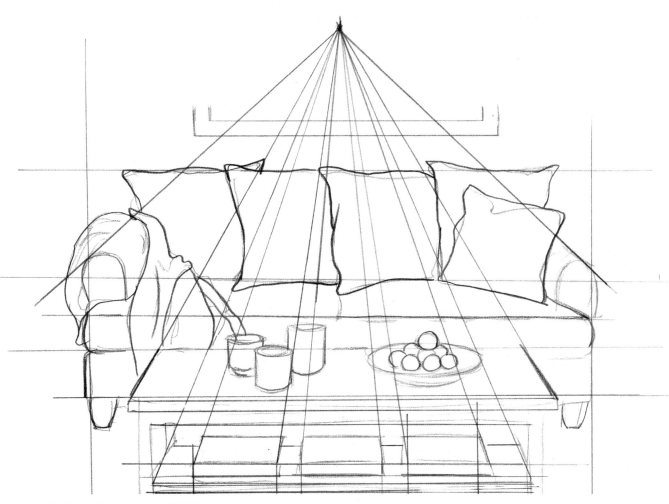

1 CREATE A WORKING DRAWING

Sketch your drawing's main shapes with a mechanical pencil following the rules of one-point perspective. To begin the rendering, remove all the working lines with a kneaded eraser and use Dark Umber to start adding the dark tones in the shadow areas.

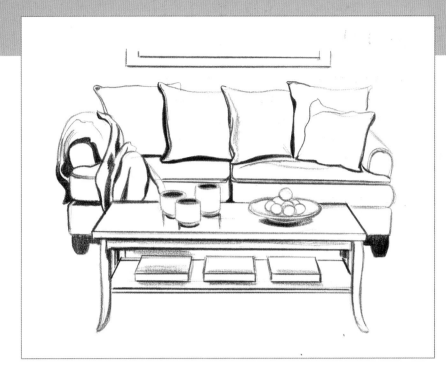

2 ADD THE DARK TONES

Add the dark tones once the working lines have been carefully removed. The darkest tones of the drawing are located in the shadow areas of the blanket on the couch and under the pillows and cushions. There are also dark shadows under the items on the table and on the couch legs.

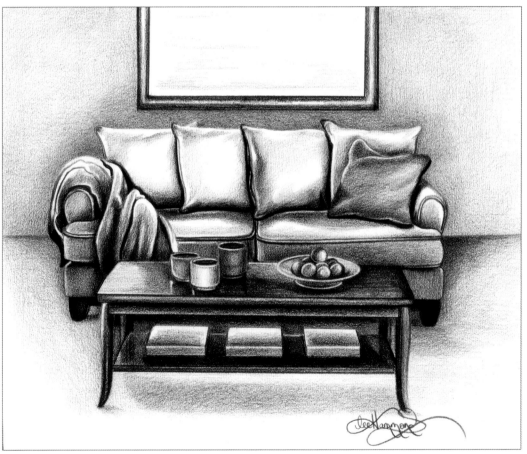

3 FINISH THE SCENE

Complete the drawing using a sharp point. Use the layering technique to achieve a great number of tones ranging from dark to light. Remember, any object with an edge or rim has reflected light. Allow your darkest tones to emphasize your light tones.

draw a house

MATERIALS

paper

Storm Blue Artagain

colors

White, Cool Grey 50%,
Cool Grey 70%, Spring
Green, Chartreuse, Dark
Green, Mediterranean Blue,
Aquamarine, Pink, Peach,
Pumpkin Orange, Dark
Brown, Cream

This drawing is one that I created for a children's book that I wrote and illustrated called A Snow Globe for Angel. *One of the characters in the story is a little boy named Andrew who lives in a mansion on a hill. I created this house purely out of my imagination, based on how I envisioned the scene. It was fun to draw, so I selected it as a project for you. It is a beneficial exercise for learning perspective.*

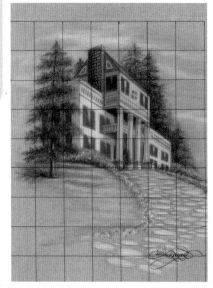

1 CREATE THE GRID AND LINE DRAWING

Use the grid method to capture the shapes of the house based on this finished reference drawing. The grid is a helpful tool for emphasizing that the vertical lines of the house are perfectly vertical. This is very important.

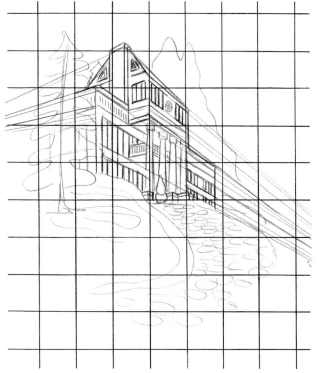

2 LOCATE THE HORIZON

The horizon line for this drawing is very low since we are looking at the house from the bottom of a hill. Notice how the perspective lines seem to go off the page toward a point on the horizon line that we can no longer see.

3 REMOVE THE GRIDLINES AND CHECK THE PERSPECTIVE

Once you have the basic outline of the house drawn on your paper, remove the grid lines carefully with your kneaded eraser. Check your perspective using this guide. Follow the working lines to see where they go, and where they will eventually converge on the imaginary horizon line. You can use a long ruler to find the point of convergence outside the paper edge, and then pivot the ruler down from one point on the house to another. To ensure accurate angles, hold the ruler tight on the horizon line point.

Use a ruler to straighten all your lines, especially the verticals. This stage is extremely important to hone the look of the finished drawing, so don't rush these important steps, even if they seem tedious!

4 DEVELOP THE FRONT AND EDGES OF THE HOUSE

The lighting in this scene is coming from the right, illuminating the front of the house. Use White to fill in the front areas. Because of the tone of the paper, the white tones really stand out.

To create the edges along the right side of the house, add Dark Green to start the shapes of the trees. Roughly apply these tones with the side of the pencil; no details are really necessary at this stage. Note that the left side of the house is partially blocked because of a tree. Apply the shapes of this tree the same way, using Dark Green.

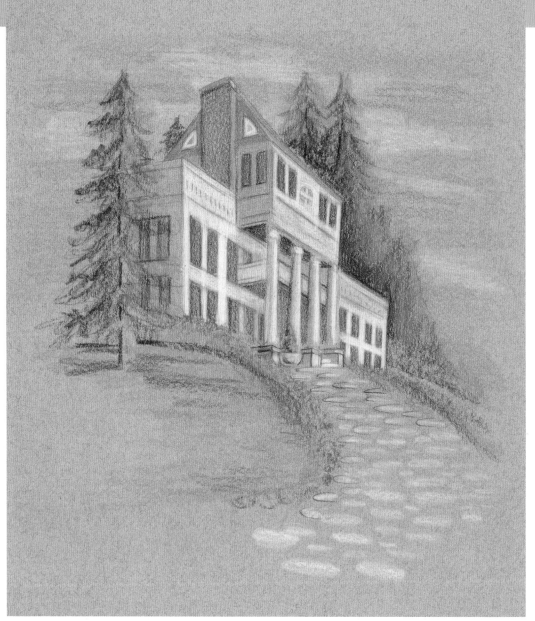

5 DARKEN THE TONES AND BEGIN THE DETAILS

The left side of the house is darker because it is not facing the light. Using Cool Grey 70%, create the deep shadow directly under the upper front of the house behind the pillars. Use Cool Grey 50% to fill in the triangular areas on either side of the chimney. Lightly add Cool Grey 50% to the rest of the left side of the house. Then, add some Aquamarine over the gray as shown. Use the Aquamarine to create the shadow side of the pillars and on the house behind the pillars. Add some Aquamarine to the sky with horizontal strokes, and to the grassy area as well.

With Spring Green, add some color to the trees and the grassy area. Detail is not important; just use the flat of the pencil to rough it in. Create the trunk of the trees with Dark Brown. This is not a solid line—it is broken up because of the tree limbs. Using Pink and the side of the pencil, loosely apply the colors of the flowers. The illusion of garden flowers is created even though you are adding little detail.

Add Mediterranean Blue to the shutters. Create the chimney with Peach on the lighter side and Pumpkin Orange on the darker side. Also use Peach on the roof. With White, render many repeating ellipses to create the look of cobblestones on the driveway. Add some Aquamarine to the stones closer to the house to achieve a shadowed look. Add more color to the sky by adding Pink and White to the Aquamarine. Use light, horizontal strokes to create the illusion of clouds.

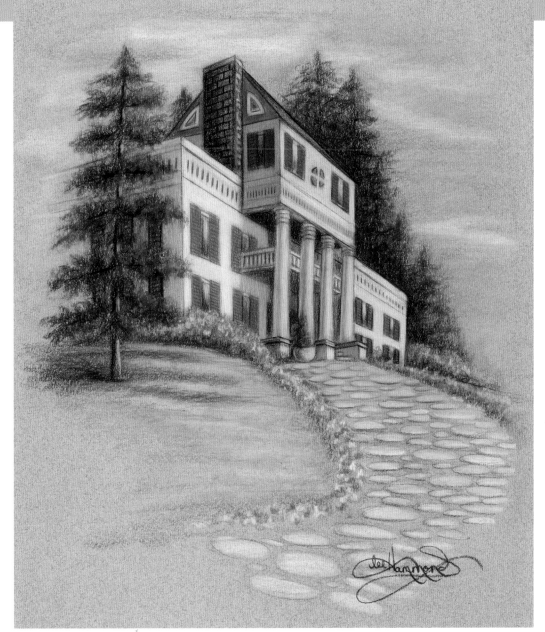

6 FINISH THE DRAWING

To finish the drawing, deepen every color's tone. Since I was not using a reference photo, I slowly added colors until I liked the look. Study the finished piece closely and you will see where all the colors have been intensified. The biggest change was in the grassy area and the flowers. Use White to give the flowers more depth, and add Chartreuse to brighten the color of the grass. Add Dark Green to create the illusion of shadow.

Use White to lighten the right side of the tree trunk, and to add highlights to the bricks on the front of the chimney. To create the patterns of the other bricks, use Dark Brown with a sharp point and a ruler. Be careful to follow the perspective lines when outlining the bricks. Add some Cream to the cobblestones along the lower portion of the driveway and also to the sky. It is a subtle color, but it adds a nice finishing touch.

THINGS TO REMEMBER

- Everything with an edge, lip or rim has reflected light along it.

- When drawing perspective remember that closer areas appear larger while areas farther away seem to shrink.

5 Fabric & Texture

When teaching, I find that many of my students will avoid heavily textured items because they seem too complicated or difficult. Textures can be a wonderful addition to your artwork and can open the door to many fun and challenging projects.

Uniquely textured objects can be found all around you. From the curtains, towels and blankets of your bedroom to the wood, stone and brick that make up the building where you live. Home improvement magazines and catalogs also offer a wealth of examples to help sharpen your skills. Start practicing, because learning to draw fabrics, folds and textures accurately can open up a whole world of artistic possibilities.

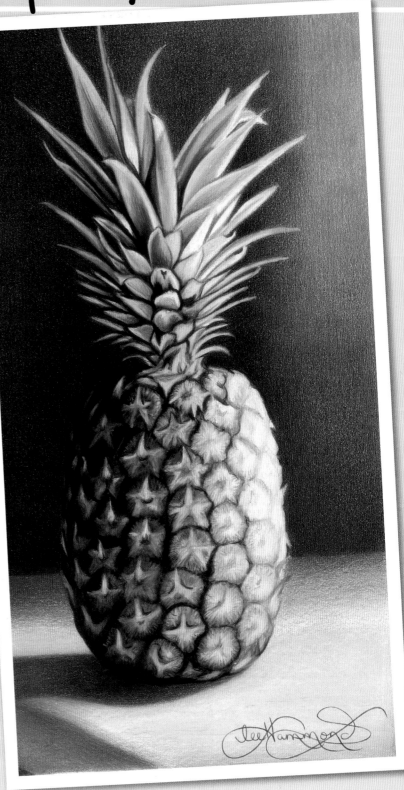

Practice Drawing Unique Textures

This pineapple is made up of a variety of interesting patterns and textures. Notice how the segments of the pineapple change depending on the lighting. They appear dark on the left side, with the underside of the flaps lighter in color. On the right side, the segments appear more of a yellow color, with the underside of the flaps darker in color. I used both layering and burnishing techniques to create the differences in surface textures.

Colors Used

Canary Yellow, Yellow Ochre, Mineral Orange, Yellowed Orange, Orange, Tuscan Red, Black Raspberry, Black Grape, Limepeel, Apple Green, Grass Green, Chartreuse, Dark Green, True Green, Sky Blue Light, Black, White

Pineapple in the Sunshine
Stonehenge paper
11" × 14" (28cm × 36cm)
Reference photo by Mel Theisen

the five basic folds

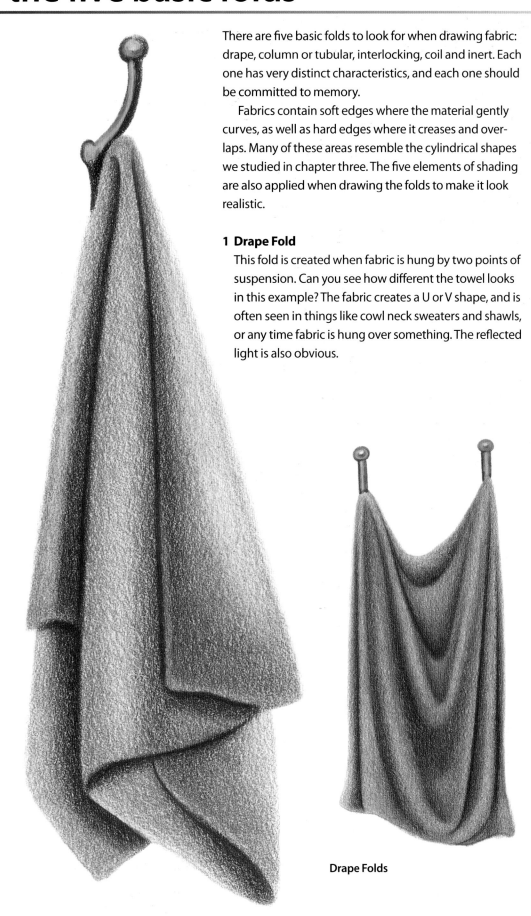

There are five basic folds to look for when drawing fabric: drape, column or tubular, interlocking, coil and inert. Each one has very distinct characteristics, and each one should be committed to memory.

Fabrics contain soft edges where the material gently curves, as well as hard edges where it creases and overlaps. Many of these areas resemble the cylindrical shapes we studied in chapter three. The five elements of shading are also applied when drawing the folds to make it look realistic.

1 Drape Fold

This fold is created when fabric is hung by two points of suspension. Can you see how different the towel looks in this example? The fabric creates a U or V shape, and is often seen in things like cowl neck sweaters and shawls, or any time fabric is hung over something. The reflected light is also obvious.

Drape Folds

2 Column or Tubular Fold

This is the most common fold, and is often seen in clothing and drapery. To recognize it, look for the cylindrical, tube-like folds that are created by the fabric being suspended by one point. It requires the same principles as drawing a cylinder, so go back and review chapter three for practice. Look at how reflected light is seen along the edges where the fabric folds and overlaps.

3 Interlocking Fold

This fold is created when fabric falls in layers, and the folds nestle inside one another. This is often seen in bulky clothing such as coats and sweaters. Note that the recessed areas are deeply shadowed.

4 Coil Fold

This fold is created when fabric is sewn into a tube shape and wraps around a cylindrical object. It is most obvious in sleeves, socks and pant legs. The fold takes on a spiral appearance.

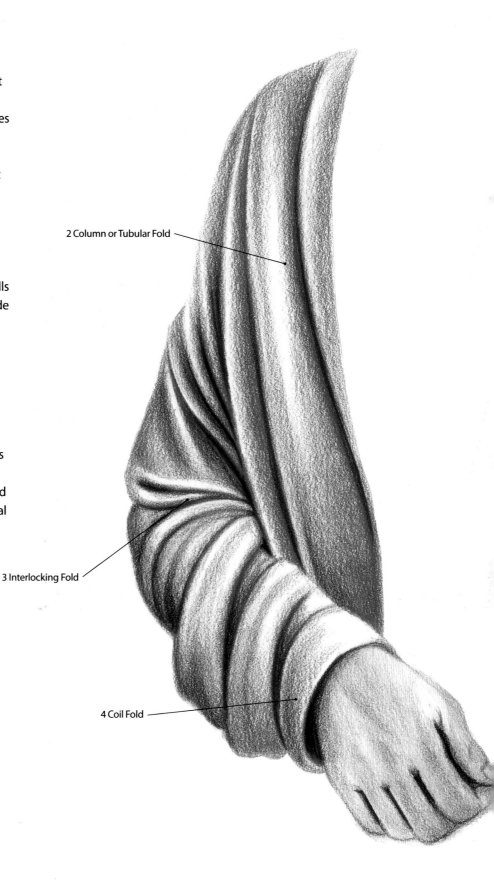

2 Column or Tubular Fold

3 Interlocking Fold

4 Coil Fold

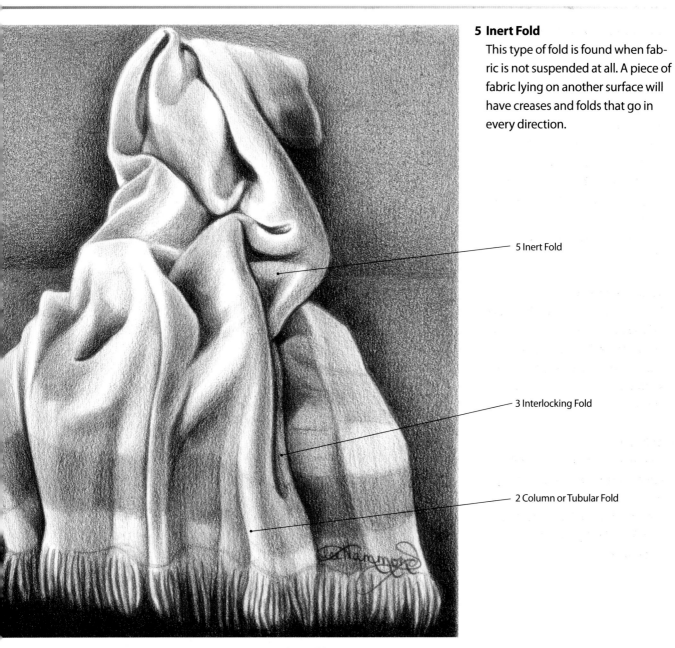

5 Inert Fold

This type of fold is found when fabric is not suspended at all. A piece of fabric lying on another surface will have creases and folds that go in every direction.

5 Inert Fold

3 Interlocking Fold

2 Column or Tubular Fold

Most Inert Folds Contain Other Folds

Look at this example of a blanket resting against a couch back. Most inert folds will also contain other types of folds as well. This blanket contains column folds where it hangs off the edge. Look closer and you can find some interlocking folds as well.

practice drawing a towel

MATERIALS

paper
Stonehenge

colors
Light Green, Aquamarine, Black

Here is the first step toward drawing fabric realistically. Follow the directions carefully, and you will see how everything we learned before about cylinders and the five elements of shading applies to fabric as well.

This towel is divided into four separate cone-shaped folds. By using the layering technique, the texture of the paper shows through, creating the texture of a terry cloth towel.

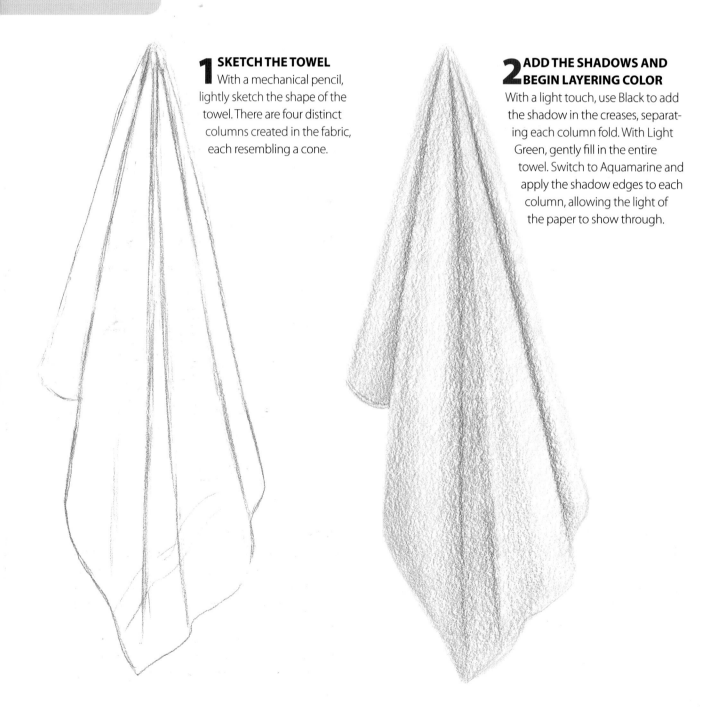

1 SKETCH THE TOWEL
With a mechanical pencil, lightly sketch the shape of the towel. There are four distinct columns created in the fabric, each resembling a cone.

2 ADD THE SHADOWS AND BEGIN LAYERING COLOR
With a light touch, use Black to add the shadow in the creases, separating each column fold. With Light Green, gently fill in the entire towel. Switch to Aquamarine and apply the shadow edges to each column, allowing the light of the paper to show through.

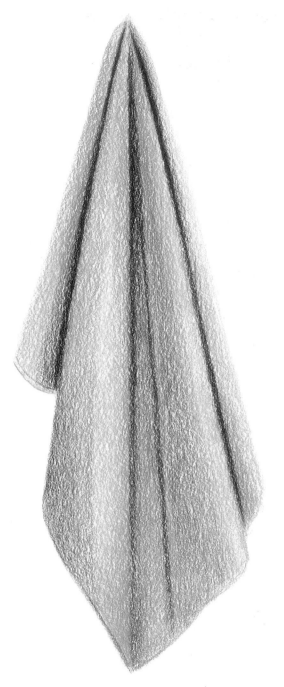

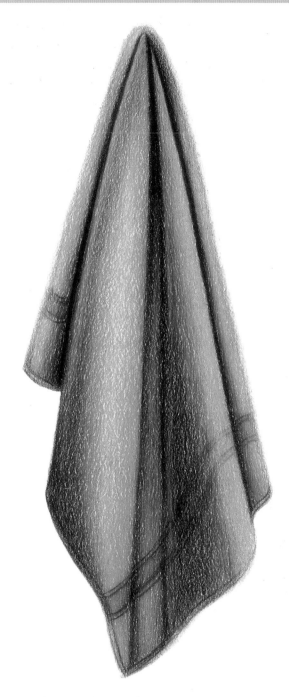

3 DEEPEN THE TONES AND SHADOWS
With a sharp pencil, deepen the overall green color of the towel once more with Light Green and the layering technique. Deepen the Aquamarine tone in the middle crease of the towel and in the other shadow areas as shown. With Black, deepen the shadow edges.

4 FINISH THE DRAWING
Repeat the previous process until the color of the towel deepens to a solid blue-green tone. Be sure to leave areas of reflected light along each of the edges, particularly where the fabric overlaps. This is what makes the surface look rounded, not flat.

When you are happy with the look of your drawing, add the border with Black and a very sharp point. Be sure the border follows the direction of the fabric, moving in and out of the folds.

wooden textures

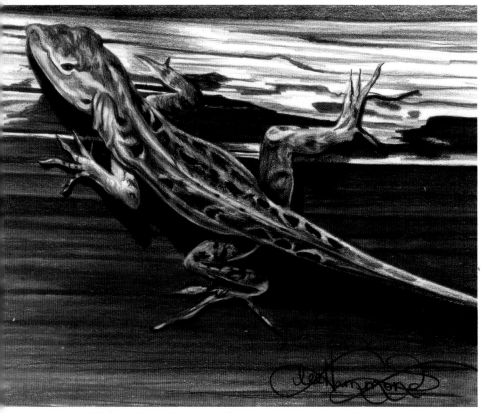

Simply put, the key to creating convincing wood textures is patience with creating multiple layers of various colors. It is very important to follow the direction of the grain when drawing wood. Wood usually has a very distinct pattern to it, and the pencil lines should replicate the design. Notice that in the illustration of the door, the wood grain is vertical. In the illustration of the lizard, the wood grain is horizontal.

Wood in Bright Light

This drawing of a has many of the same colors and techniques as the drawing of the wooden door handle at right. However, to represent the intense light of the sun, the colors have been burnished to appear brighter. The orange color of the wood is reflected in the textured skin of the lizard, and the blue of the sky is repeated in the white part of the wood above him.

Colors Used
Beige, Burnt Ochre, Terra Cotta, Orange, Tuscan Red, Cool Grey 50%, Aquamarine, Black, White

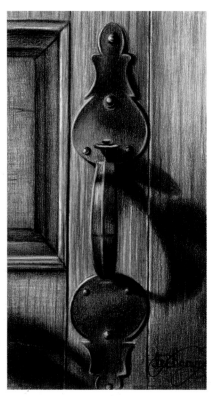

Vertical Grain Wood

Many layers of different colors combine to make the wood look realistic. This drawing was created on #1008 Ivory mat board, so the wrought iron texture of the paper shows through to create the pebbly texture of the door handle.

Reference photo by Janet Dibble Wellenberger

Colors Used
Yellow Ochre, Burnt Ochre, Sienna Brown, Terra Cotta, Orange, Tuscan Red, Dark Brown, Dark Umber, Black, White

Most wood grain has many colors and patterns. It's easy to draw when broken down into these three layers: the undertone, the pattern and the shine on top.

MATERIALS

paper
Stonehenge

colors
Yellow Orange, Dark Brown, Tuscan Red

1 SKETCH THE LINE DRAWING
Lightly sketch the patterns of the wood grain with a mechanical pencil. Go over the lines with Dark Brown and a sharp point.

2 DEEPEN THE TONES
Start with the lightest color first—in this case, the Yellow Orange. Using the layered approach, place the wood grain lines down horizontally. With Dark Brown, create the oval shapes of the wood grain. Add some horizontal lines with Tuscan Red to create more of the wood grain.

3 BURNISH THE COLORS AND FINISH THE DRAWING
Continue to build up the colors with more pressure until they burnish together. Keep applying pencil lines, alternating back and forth between light and dark until the look of wood grain is achieved.

brick

Bricks create an interesting background pattern to a drawing because each brick is totally different from another. No two are exactly alike.

It is important to draw bricks accurately and in perspective. Refer to the perspective basics on page 51 when choosing to include bricks in your drawings. Without the proper angles and vantage point, placing bricks in your drawing could throw the whole thing off.

Practice Drawing Contrasting Textures and Colors

I am drawn to subjects that have multiple contrasting textures, like this drawing of a decanter on the mantel. The smooth, shiny surface of the glass against the bricks is not only a contrast of texture, it is a complementary color scheme. There are thousands of textures in the world, and each one offers artists a wonderful creative opportunity.

Colors Used

Yellow Ochre, Mineral Orange, Terra Cotta, Tuscan Red, Dark Brown, Dark Umber, Sienna Brown, Dark Green, Peacock Green, True Green, Indigo Blue, Apple Green, Cool Grey 50%, Cool Grey 70%, Crimson Red, Black, White

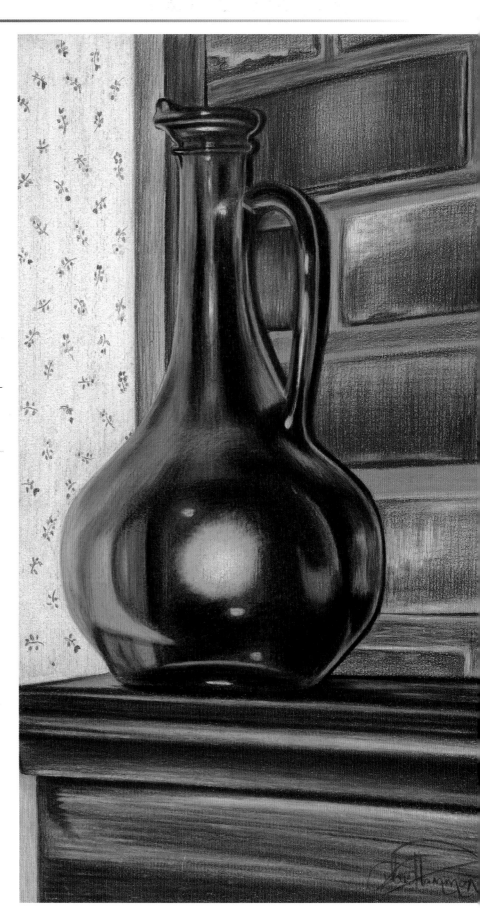

draw bricks

The patterns that bricks create can turn a simple drawing into an interesting piece. Here is a small practice exercise to help you learn to draw this wonderful textured object.

MATERIALS

paper
Stonehenge

colors
Mineral Orange, Tuscan Red, Cool Grey 50%, Black, Dark Umber, White

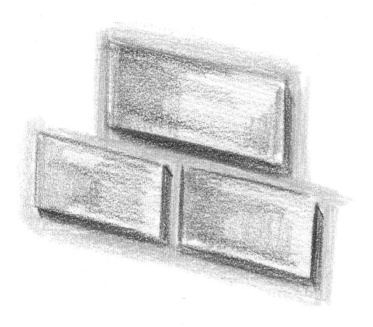

1 SKETCH THE BASIC SHAPE AND BASE IN THE LIGHTEST COLORS

Draw out the bricks with a mechanical pencil. (Remember your rules of perspective!) Layer in the lightest color of the brick first—in this case, Mineral Orange. Add Tuscan Red to the sides and bottom edge of the bricks. Add some Tuscan Red to the surface on top of the orange color. With Cool Grey 50%, add the mortar around the bricks.

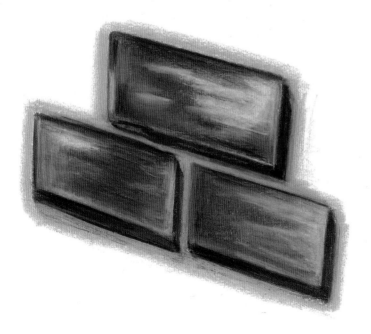

2 BURNISH THE COLORS AND HONE THE EDGES

Build up the colors so they burnish. Add Dark Umber to create some of the darker color and texture. (Note that these bricks do not have the same amount of texture as the one in the finished illustration on page 68.) Use White to create the lightest color on top. Use Black to create the edges.

stone

Stones, pebbles and rocks can add wonderful texture to your drawings. This pot from Pompeii is beautiful, but alone in a drawing it would be somewhat lackluster. The real beauty of the drawing is created by all the surrounding stonework. The contrasts of color, texture and size relationships of the different stones and pebbles bring the pot into a realistic context.

Study and practice the close-up exercises of the textured areas on the next page.

THINGS TO REMEMBER

- Commit the five basic fabric folds to memory.
- Consider using extreme lighting when taking reference photos to give your artwork extra spark.
- Always follow the direction of the grain when drawing wood.
- Make sure you have an accurate vantage point and angles when placing bricks in a drawing.
- Think of stones and pebbles abstractly when drawing them. They should interlock like puzzle pieces.

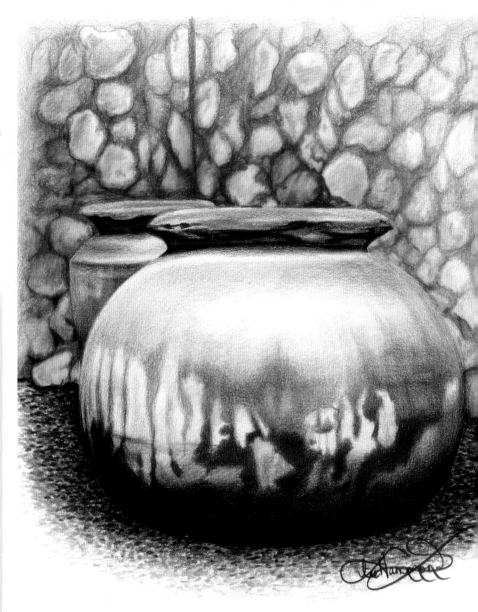

Preserve Your Travel Memories With Drawings

This was a pot I saw on a recent trip to Pompeii, an ancient city located in western Italy that was buried by the volcanic eruption of Mt. Vesuvius nearly 2,000 years ago. I love the texture of the clay pot, and the variance of colors within its surface.

Colors Used

Peach, Yellow Ochre, Sand, Henna, Terra Cotta, Tuscan Red, Dark Brown, French Grey 20%, Cool Grey 50%, Cool Grey 70%, Black

pebbles and stones

When drawing pebbles and stones, think of them abstractly. Small pebbles are a series of tiny circular marks, and wall stonework is a puzzle of inter-locking shapes. Follow along with these exercises and see for yourself how simple it can be!

MATERIALS

paper
Stonehenge

pebble colors
Cool Grey 50%, Slate Grey, Greyed Lavender, Sand, Peach, Black

stone colors
French Grey 30%, Cool Grey 50%, Beige, Clay Rose, Cool Grey 70%

1 CREATE THE LINE DRAWING

With Cool Grey 50%, hold the pencil slightly on the side and create tiny, circular marks. Render them ellipti-cally, not in complete circles. Allow the tones to vary from dark to light.

There is no need to draw all the pebbles in the line drawing. Since pebbles are small and overlap one another, you must build them in layers.

2 OVERLAP MORE PEBBLES

Alternating all the colors from the list, create the same small, oval marks with the side of the pencil. Overlap the marks and the colors for variety, creating the illusion that they are placed on top of one another. Add realism by varying each pebble's size.

3 FINISH THE DRAWING

Use a variety of gray tones and Black, with a touch of Peach and Sand, to layer color on each pebble.

The colors of the pebbles should vary depending on the shadows. Notice how they are darker when closest to the pot, and more colorful when they are closest to the viewer.

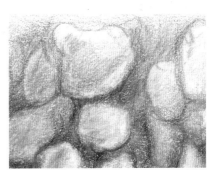

1 SKETCH THE BASIC PATTERNS AND BURNISH THE UNDERTONE

With a mechanical pencil, lightly sketch in the patterns of the stones that form the stone wall. They should interlock like pieces of a mosaic.

Once the shape of each stone is drawn, burnish them with French Grey 30% to create the undertone.

2 LAYER THE TEXTURE AND COLOR

Layer Beige and Clay Rose on top of the burnished gray undertone to create the texture and color of each stone. Vary the colors, creating no two stones alike. You may choose to make some darker by using various Cool Grey tones.

For the mortar around the stones, apply Cool Grey 50% using a light touch. Outline the edges of each of the stones with Cool Grey 70%.

3 FINISH THE DRAWING

Continue building the colors in the different stones. Some should appear beige, others darker and gray. Continue adding color until you are happy with the texture and tone of each stone.

71

6 Transparent Objects

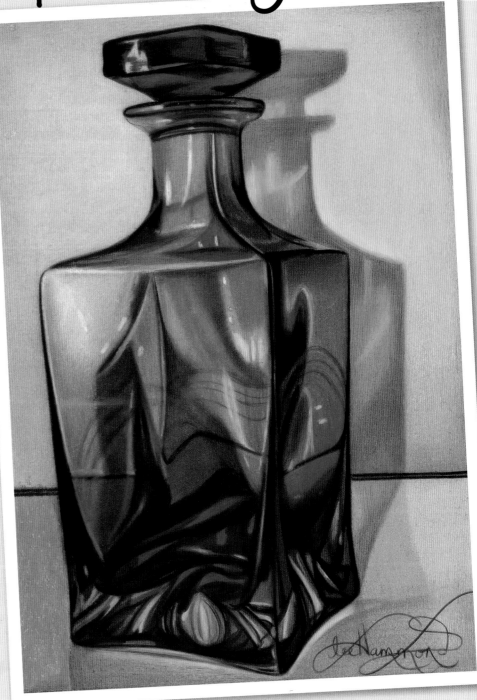

When you draw something transparent, you render everything that reflects off it, rather than the actual object. Instead of visualizing these objects as "clear," think of them as a shiny surface that reflects shapes and tone to create different patterns.

Experiment with drawing glass objects by placing them with various light sources and viewing them from multiple positions. Once you get used to viewing glass as patterns of shapes and tones, you'll find there is no end to the possibilities of the beautiful colors that glass creates.

Experiment With the Lighting and Posing of Glass Objects

This blue decanter from my kitchen is a wonderful example of reflected color and light. My close friend Tice took about twenty pictures of this decanter with different angles, lighting and backgrounds. We moved it in and out of light and were amazed at how different each photo appeared.

Colors Used

Cream, Sand, Peach, Mineral Orange, Tuscan Red, Burnt Ochre, Magenta, Clay Rose, Lavender, Black Raspberry, Indigo Blue, Denim Blue, True Blue, Sky Blue Light, Black, White

A Blue Decanter From the Kitchen
Stonehenge paper
11" × 14" (28cm × 36cm)
Reference photo by Mel Theisen

Try this exercise of drawing a glass of milk. The most important aspect of this drawing is achieving accurate ellipses shapes in the rim and the bottom of the glass. Start with the basic cylindrical shape, and follow along.

MATERIALS

paper
Stonehenge

colors
Greyed Lavender, Cool Grey 50%, Cool Grey 70%, Black

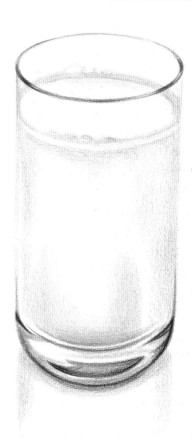

1 CREATE THE LINE DRAWING
With a mechanical pencil, lightly draw the shape of the glass: a cylinder and two ellipses. Add Greyed Lavender to the milk line and the shadow edges in the glass. Repeat this color in the bottom of the glass and in the reflection on the table.

2 DEEPEN THE TONES
With Cool Grey 70%, deepen the color around the rim. With a sharp point, render a double line to depict the thickness of the glass. Create the pattern in the bottom of the glass.

3 FINISH THE DRAWING
Add some Greyed Lavender to the rim of the glass within the double line. With Cool Grey 50%, add the shadow to the inside bottom of the glass and to the reflection on the table. Finish the drawing by deepening the patterns in the bottom of the glass with Black.

73

wine glasses

MATERIALS

paper
Stonehenge

colors
Periwinkle, Lilac, Violet, Cloud Blue, Clay Rose, Cool Grey 50%, White

Drawing glassware is all about creating illusions. It is very important to draw from observation, not from memory. Our memories will trick us because we know glass to be "clear." These wine glasses reflect surrounding colors, making them appear quite colorful. The shapes are very symmetrical, so it is helpful to visualize the center point of the stems to ensure accuracy in shape. Also refer to the ellipses instruction in chapter three when drawing the rims and bases.

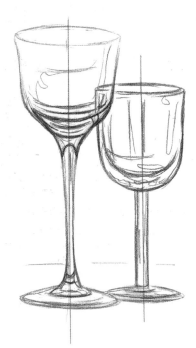
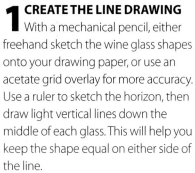

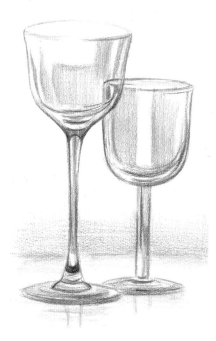

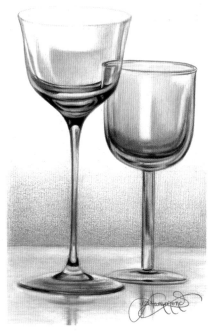

1 CREATE THE LINE DRAWING
With a mechanical pencil, either freehand sketch the wine glass shapes onto your drawing paper, or use an acetate grid overlay for more accuracy. Use a ruler to sketch the horizon, then draw light vertical lines down the middle of each glass. This will help you keep the shape equal on either side of the line.

2 BEGIN LAYERING THE COLORS
With a sharp point, layer the blue areas with Periwinkle. Use Lilac to create the lavender shapes in the glasses, the reflections below the glasses and the area above the horizon line. With Cool Grey 50%, draw the dark patterns in the glasses. Leave the bright highlight areas empty, with the white of the paper exposed. Note the areas of reflected light that the round shapes create along the edges of the glass and stems.

3 FINISH THE DRAWING
Deepen all the colors and add Cloud Blue to the tabletop using horizontal pencil strokes. To make the background stand out more against the glasses, add a touch of Clay Rose over the Lilac already applied.

Burnish the tabletop with Cloud Blue to make it look glossy and reflective. Leave the background layered to give the drawing some textural contrast.

practice with unique glass patterns

As an artist, I am always attracted to unusual colors and shapes. While visiting a friend in Mexico, I was struck by this unique bottle sitting in her kitchen. I loved the way its asymmetrical shape reflected colors; I simply had to take a picture of it knowing I would someday turn it into art in my studio.

To create interesting reference photos of the bottle, I took it outside and placed it on the steps in her backyard. Notice the blue of the sky reflecting in the glass, and the colors of terra cotta tiles shining through. I used a heavily burnished approach in this drawing to make the colors shiny and vivid.

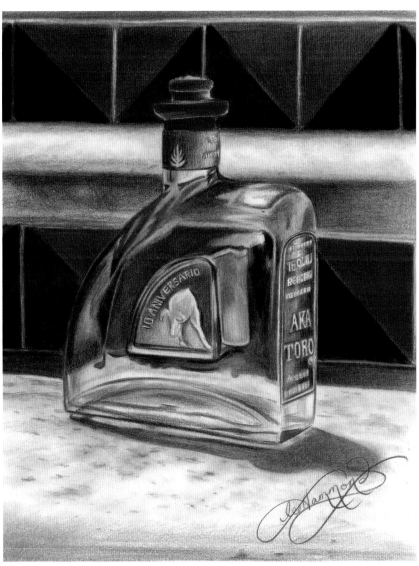

Create Fine Details With a Craft Knife

The tiny lettering on the bottle is best etched out with a small craft knife. The sharp blade removes thin hairlines of the pencil wax to achieve a delicate result.

Use the craft knife anytime you need a clean edge or tiny line of light in a drawing.

Practice Drawing Asymmetrical Objects

The asymmetrical shape of a tequila bottle inspired this drawing. Look for unique glass items like this to draw, and study them as abstract objects. Squint your eyes to detect all the light and dark patterns that make up transparent objects.

Colors Used

True Blue, Aquamarine, Dark Brown, Light Umber, Terra Cotta, Poppy Red, Yellow Ochre, Tuscan Red, Black, White

LEE'S LESSONS

It is essential to have a good layer of pencil wax on the paper before scratching away with a craft knife. You don't want to accidentally gouge your paper!

glass basket

MATERIALS

paper
Stonehenge

colors
Pink Rose, Hot Pink, Crimson Red, Cool Grey 50%, Cool Grey 70%, White

Sometimes glass can be very complicated—not only in color, but in shape. This little Fenton glass basket is decorative and delicate looking with its ruffled edges and braid-like handle. Such details must be studied carefully. Use the grid method to draw these shapes accurately, studying how the shapes of the glassware are captured within each box.

Reference Photo

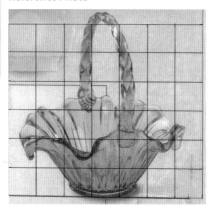

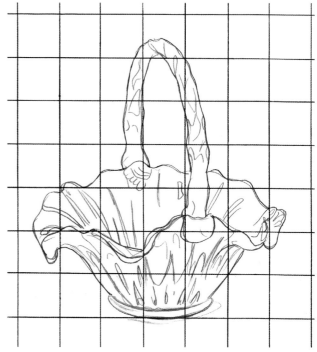

1 CREATE THE LINE DRAWING
With a mechanical pencil, very lightly draw a grid on your drawing paper with the same number of boxes as the photo. Study the shapes inside and recreate them in each square. When you are happy with your drawing, erase the grid lines with your kneaded eraser.

2 OUTLINE THE EDGES AND BEGIN THE PATTERNS
Start with just a few key lines of color. It is important to create the edges and patterns of the glass right away so they don't get lost later. Draw in the lines as shown with Crimson Red. This creates the edges and side of the glass and begins the patterns of color. Add some to the handle, too. Notice that the lines are broken and fragmented because of the reflections of light on the basket.

With Cool Grey 50%, add more lines to continue building the edges and details of the basket and handle.

76

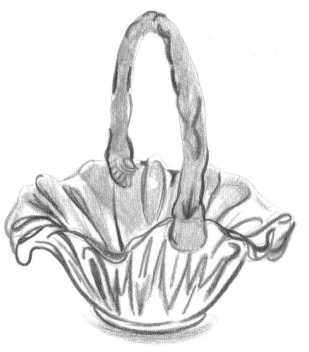

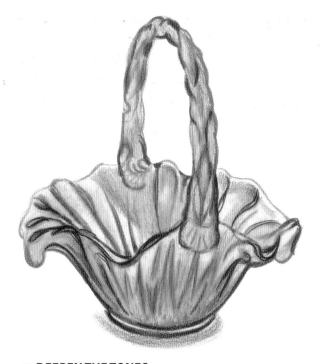

3 **BEGIN PLACING THE BASE COLORS**
Use Crimson Red to add more lines to the top edge of the handle, and more streaks into the body of the basket. With Pink Rose, lightly fill in the handle, overlapping the colors already there. Add this color to the inside of the basket as well.

4 **DEEPEN THE TONES**
Fill in the front of the basket with Hot Pink. Overlap the colors already in place, but leave a bit of white showing along the upper edge. This gives the basket its color, and also begins the shine of the glass. Add some Hot Pink to the inside of the basket to deepen the look of the shadow. Make note of the shadow's diagonal edge.

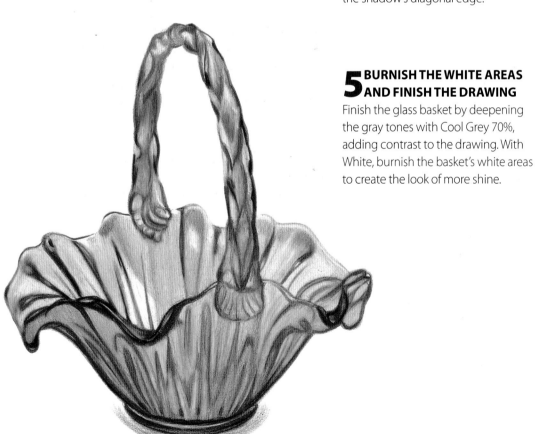

5 **BURNISH THE WHITE AREAS AND FINISH THE DRAWING**
Finish the glass basket by deepening the gray tones with Cool Grey 70%, adding contrast to the drawing. With White, burnish the basket's white areas to create the look of more shine.

glass of ice water

MATERIALS

paper
Stonehenge

colors
Black, Copenhagen Blue

Glass is very reflective. Not only does it pick up reflections of color and shapes from its surroundings, its appearance is affected by what is inside it. This glass of ice cubes is an amazing collection of patterns and geometric shapes. Use this graphed photo to obtain an accurate line drawing. Don't worry too much about drawing perfect shapes—the illusion of cold ice cubes will be created once you add the tones.

Reference Photo

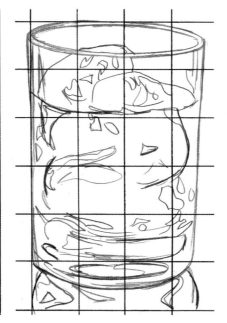

1 CREATE A LINE DRAWING
Use the grid to create an accurate line drawing with a mechanical pencil. Every little shape need not be perfect, just try to capture the nonsense patterns of the cubes. Make sure the arcs of the ellipses are rounded at the ends, not pointy.

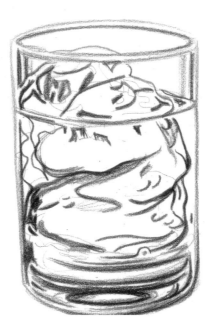

2 OUTLINE THE EDGES AND PATTERNS
Start your drawing with Black and a very sharp point. Render the ellipses that create the rim of the glass and the bottom. Then, study the shapes of the ice cubes, and add thick and thin lines to build the patterns.

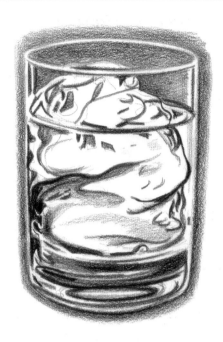

3 CONTINUE TO DEEPEN THE TONES

With Black and a sharp point, add some tone to the background surrounding the glass. Layer this color around the entire glass. Add some tone to the inside of the glass to create the swirls in the ice.

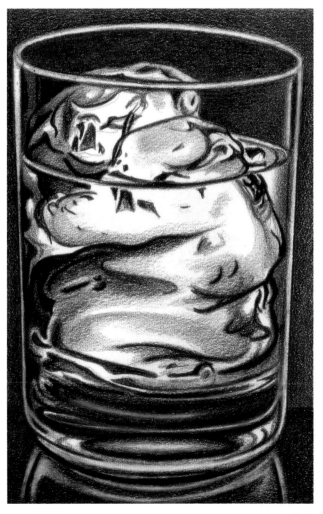

4 CREATE THE BACKGROUND AND FINISH THE DRAWING

With a ruler and the Black pencil, create clean, straight sides of the glass and draw a horizontal line to create the illusion of a tabletop. To give the drawing more of a finished look, create a rectangular box around the glass for a border.

With Copenhagen Blue, overlap the black in the background, and fill it in toward the edges of the border. Using a sharp point on your pencil, fill it in slowly to make the tones even and smooth. Lightly add some Copenhagen Blue to the ice and insides of the glass. Be sure to leave the bright white edges of the glass empty for extra shine. With Black, fill in the tabletop. Allow the reflection shapes below the glass to remain white.

opaque and semitransparent objects

Not all glass is transparent. Some is very opaque; some is semitransparent. Every object must be carefully studied and analyzed before you begin to draw it. Look for variances in color, and for any colors that may be reflected from outside sources. Drawing a nontransparent glass object can be fun and challenging. Remember, just because it varies in color doesn't mean it is reflecting light.

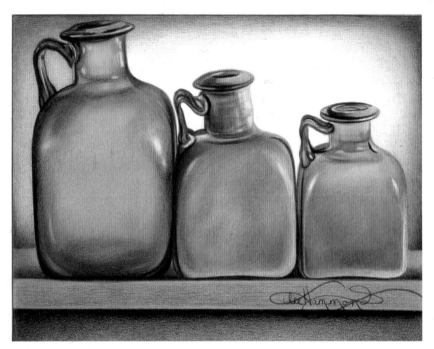

Semitransparent Glass

These measuring jars were part of a collection dug up in the ruins of Pompeii. Each one is exactly one half the size of the one next to it.

The glass used in these jars is semitransparent—you can just barely see through it. When you look at these jars, the color is very inconsistent. It goes in and out of dark and light. Some areas look very bright, and the color looks pure. Other areas appear dense in color, and somewhat cloudy and dull.

Colors Used

Light Aqua, Aquamarine, True Blue, Pale Sage, Light Green, Denim Blue, Cool Grey 70%, Cloud Blue, Black, White

Burnish for Smooth Glass Texture

Burnishing blends colors together, giving them a very smooth texture, adding a shine to highlighted areas. Notice how the highlights show off the curves of the sides of the jars, yielding a three-dimensional look.

Close-up of Background Shadows

Use a small amount of shadow color in the background to make a drawing appear finished. Adding a border around your drawing will concentrate the colors in the corners and lead the eye to the middle, where the main subject is.

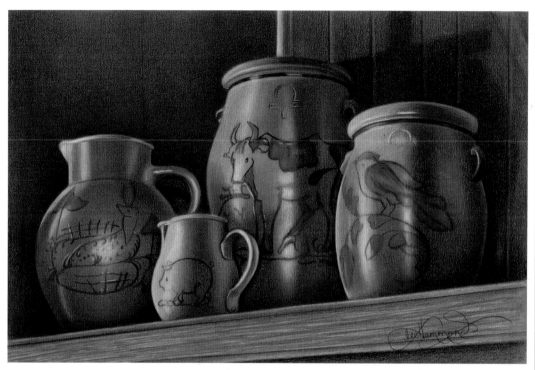

Practice Drawing Opaque Objects

Much like glassware, crockery's surface is reflective but opaque. You cannot see through it. Because crockery has a somewhat porous texture and the amount of glaze varies from piece to piece, it isn't always as shiny as regular glass.

I created the crocks in this drawing using the layering technique on Gotham Grey Artagain Paper. Choose a shade of paper that closely matches the tone of the pottery's porous surface to help emphasize its texture.

Colors Used

Peach, Burnt Ochre, Dark Brown, Dark Umber, French Grey 20%, French Grey 70%, Indigo Blue, True Blue, Black, White

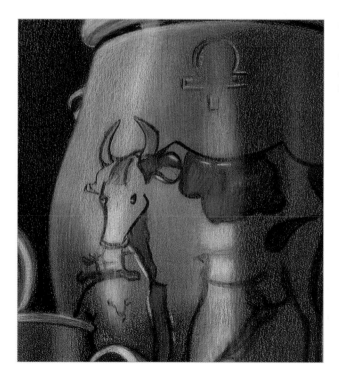

Highlights Help Create Roundness

I applied White to the crocks to create the highlight areas and give them a shiny appearance. These highlights really help strengthen the roundness of the form.

LEE'S LESSONS

Try cropping your photos for unique compositions. This drawing is an example of a segment drawing (see page 33). The original photo was of an entire kitchen scene. In the background, there where many shelves full of household items—this is only a small portion of the original photo. I deliberately cropped the image so it included the interesting shadows in the background. I also cropped the crock on the left for better composition. Cropping is an effective way of balancing the shapes. If I had left the entire image showing, everything would have looked centered and a bit artificial.

reflective opaque glass

MATERIALS

paper
Stonehenge

colors
True Blue, Non-Photo Blue, Imperial Violet, Violet Blue, Process Red, Black, White

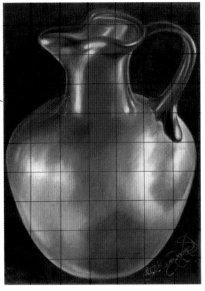

Reference Photo

This shiny glass pitcher is similar to the measuring jars on page 80. It also came from the ruins of Pompeii. If you look closely, you can see a variety of colors in the lights and darks of the pitcher's curves, though the overall color is a dark blue. There is even some magenta bouncing off objects in the background. I chose a solid black background to intensify the colors of this pitcher. It really helps the round edges stand out.

1 CREATE THE GRID AND LINE DRAWING

With a mechanical pencil, very lightly draw a grid on your drawing paper and recreate the jug. When you are happy with your drawing, erase the grid lines with your kneaded eraser.

2 LAYER THE INITIAL COLOR PATTERNS

Using the layered approach, apply the darkest shapes first with Imperial Violet. These curved shapes create the illusion of roundness (see the five elements of shading on page 26).

With True Blue, add the blue tones, leaving the white of the paper exposed for the highlight areas.

3 OUTLINE THE HIGHLIGHTED EDGES AND BURNISH THE DARK TONES

Add Black around the jug to make the bright, highlighted edges stand out. The rest will be filled in later. These edges are very important to this drawing, so take care not to lose them as you layer the drawing.

Build up the colors from step 2 using the burnishing technique so they cover the paper more completely. Deepen the darker areas of the jug with Violet Blue using a heavier application when applying the color. Also go over the areas of True Blue to deepen them using heavy pressure on the pencil.

Apply a small amount of Process Red to the edges and rims to create a subtle hint of reddish reflection in the glass.

4 CONTINUE BURNISHING AND FILL IN THE BACKGROUND

To create a shiny, finished look, continue burnishing the colors so they build to completely cover the paper. You do not want to see any of the paper's texture coming through. Use White to burnish the highlight areas, then add a bit of the Imperial Violet to the highlights. Continue burnishing with White to blend them together.

Fill in the background with Black using firm pressure and many layers. When you are completely finished, spray the piece with a fixative to keep the drawing from appearing hazy. This is necessary because of the heavy build-up of Black in the background. Without the fixative, the wax from this layer of pencil will rise to the top of the paper, causing a cloudy, dull look.

demonstration
nontransparent bowl

MATERIALS

paper
Moonstone Artagain

colors
Putty Beige, Clay Rose, Henna, Black Raspberry, Dark Brown, Indigo Blue, Burnt Ochre, Black, White

We've already practiced how to draw transparent glass objects. Now, let's try to draw some crockery. While it is not transparent, the surface of this sugar bowl is smooth, shiny and porous, and the type of paper you choose can help create this look. For this drawing, I chose a piece of colored paper that was very close to the color of the crockery. Using the layering technique allows the paper color to show through, enhancing the overall colors of the bowl.

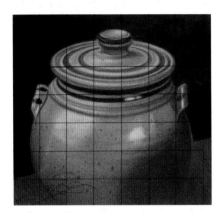

Reference Photo

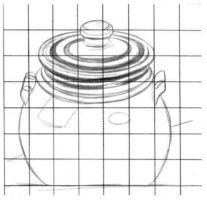

1 CREATE THE GRID AND LINE DRAWING

The ellipses required for this drawing are easier to obtain when using the grid method. Because there are so many, it might help to fill in the dark lines around the top and the neck of the bowls as you draw. This will help you avoid confusion among the many individual lines.

The ellipses are the most critical aspect of this drawing. Before adding any colored pencil, work on the ellipses with a mechanical pencil until they appear correct. It is much better to make corrections with regular graphite than colored pencil because graphite erases much easier.

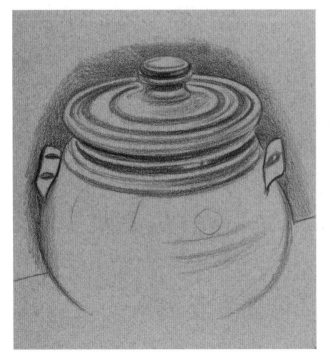

2 DEFINE THE EDGES AND BEGIN THE BACKGROUND

With Black and a very sharp point, create the edges of the bowl and apply a light layering of tone to the background. Work on the accuracy of the shapes of the ellipses and lightly fill them in to create the patterns. With Black Raspberry, create the edges and rim of the bowl to continue building the ellipses.

THINGS TO REMEMBER

- Think of transparent objects as shiny surfaces instead of "clear." You draw everything that the object reflects, not the object itself.

- Draw glassware from observation, not memory.

- Have a good layer of pencil wax on the paper before using a craft knife.

- Just because an object's color varies does not mean it's reflecting light.

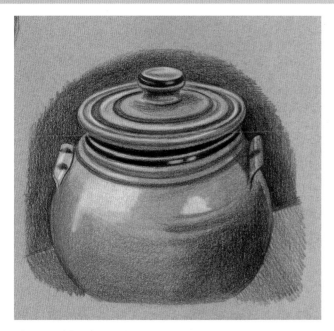

3 DEEPEN THE TONES AND CREATE THE SHADOWS
Once you have achieved accurate ellipses, deepen the colors of the stripes around the neck and the top of the bowl with Indigo Blue. Also add the small patterns to the handles with Indigo Blue.

Deepen the overall color of the bowl using the layering technique. This allows the color of the paper to come through, further enhancing the look of pottery. With Henna, deepen the color in the lower area of the bowl. Use Clay Rose to help the Henna color transition toward the upper area of the bowl.

Create the shadow on the right side of the bowl by layering Black. Notice the cast shadows to the right of the knob on the lid and to the left of the handle on the right. Deepen the tone in the background with Black.

Add Burnt Ochre to the tabletop on the left, and Black Raspberry to the tabletop on the right. Lightly apply White to begin the highlights.

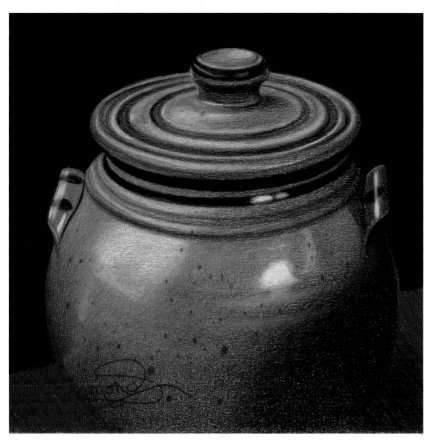

4 BURNISH THE BACKGROUND AND DEEPEN THE HIGHLIGHTS
Deepen all the tones with multiple layers of color, and burnish the background until smooth, using a ruler to create a definitive border.

Create the table's wood grain look, keeping in mind the perspective of the pencil lines. Build the wood color with Burnt Ochre, and the wood grain with Dark Brown. Render the cast shadow on the right with Black Raspberry.

Slowly build the color of the sugar bowl with the layered approach. It is important to not allow the colors of the bowl to burnish—creating a smooth and reflective surface would take away from the realistic appearance of crockery.

Shadow the top of the lid and in between the stripes on the neck with Dark Brown. Layer the rest of the bowl with more Henna and Black Raspberry, allowing the paper color to show through.

To finish the drawing, deepen the White highlights, then add the small freckles of the crockery with Dark Brown.

Metallic Objects

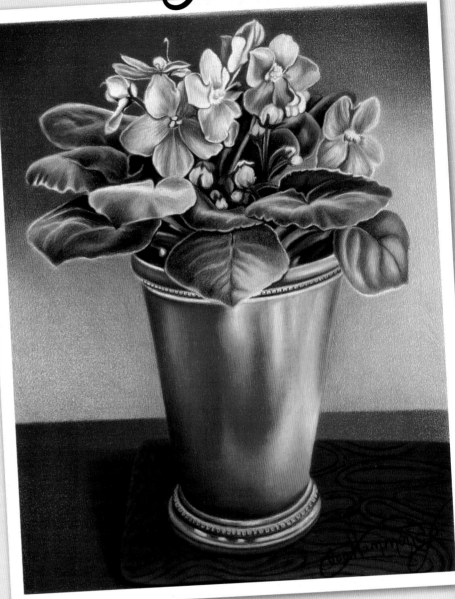

Drawing a metallic surface is very much like drawing glass. They both have highly reflective surfaces, which create extreme patterns of light and dark. When drawing an object in color, you must remember to look for colors reflecting from the object's surroundings.

At right is a drawing of an old-fashioned metal vase. While the real color of the vase is a light pink, the bright colors of the surroundings and background change the vase's appearance dramatically.

Practice drawing the different types of metal surfaces in this chapter. Each one is very different from the other, depending on its surface, color and surroundings.

African Violets in Metal Vase
Stonehenge paper
11" × 14" (28cm × 36cm)

Accent Your Subject With Strong Background Tones

The colors of the background fading from dark to light help accent the colors of the African violets and the vase. You can use complementary colors to make your drawing subjects pop. To make the green colors of the leaves stand out, I used an abundance of red throughout the drawing. The violets stand out because of the yellow in the background.

Colors Used

Dark Purple, Mulberry, Magenta, Crimson Red, Poppy Red, Process Red, Tuscan Red, Salmon Pink, Orange, Canary Yellow, Violet, Lavender, Lilac, Limepeel, Marine Green, Dark Green, Dark Brown, Black, White

polished silver & stainless steel

Polished silver and stainless steel are extremely shiny, with many extreme reflections and tones. They are best created using the burnishing technique with a heavy application of tones and colors. Remember, smooth surfaces are burnished and porous surfaces are layered.

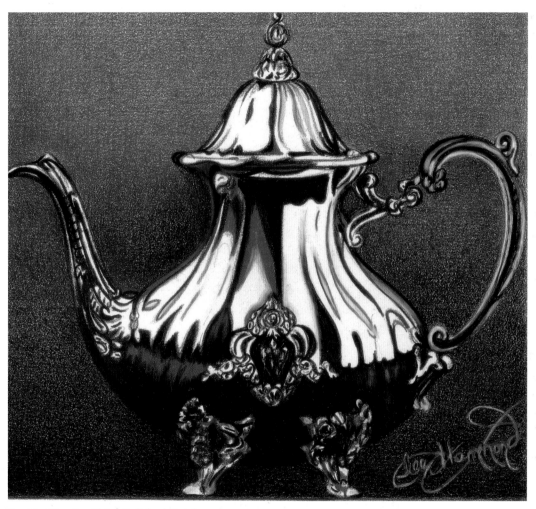

Practice Drawing Shiny, Polished Metals

This shiny and polished silver creates powerful extremes of tone and reflected shapes. The lighting is coming from the top, creating intense contrasts. The top looks extremely light, while the bottom is extremely dark.

The dark, layered background of this drawing contrasts sharply against the shiny surface of the teapot. This drawing was rendered entirely in gray tones. Because the background is all shades of gray, there are no reflecting colors in this piece like the drawing of the goblet on page 92. A dark background is very important with polished silver, because it helps the light edges of the object stand out, and it gives stark contrast to the white areas.

I used the layering technique in the background to contrast against the heavily burnished approach used in the surface of the teapot.

stainless steel saucepan

MATERIALS

paper
Stonehenge

colors
Metallic Gold, Black, White

When drawing silver or stainless steel in colored pencil, it is important not to use just black and white. Your drawing will appear more realistic if you add some color. In this piece, I used some Metallic Gold to make the saucepan less stark. Follow along and draw the saucepan.

Reference Photo

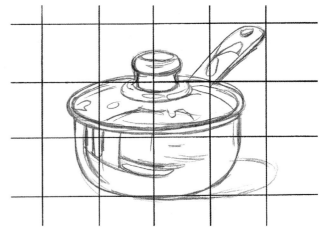

1 CREATE THE LINE DRAWING

Create an accurate line drawing using the reference photo. Carefully remove the grid lines with a kneaded eraser.

2 CREATE THE DARK PATTERNS

With Black and a very sharp point, create the dark patterns of the saucepan and lid.

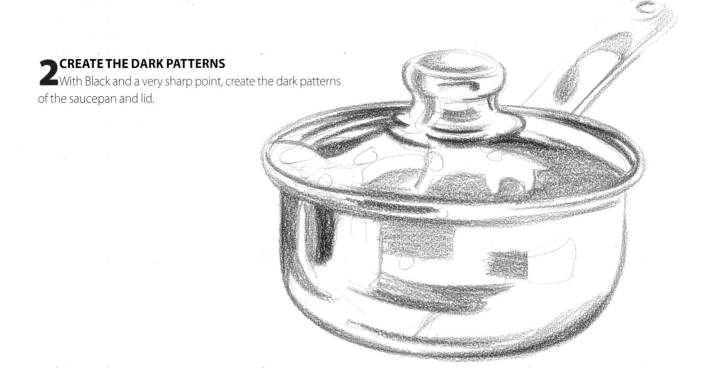

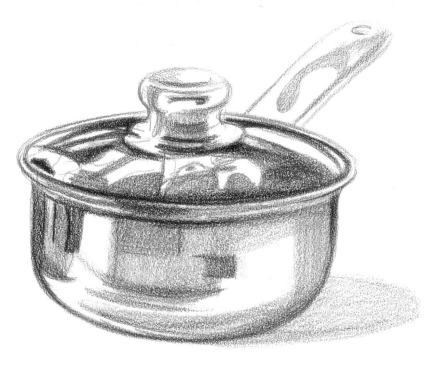

3 DEEPEN THE DARK TONES

Deepen the darker patterns with Black. Add Metallic Gold to create the shadow cast to the right. Layer the gold patterns of the pan's base and the lid. Leave the bright highlight areas the white of the paper.

4 BURNISH THE COLORS

Burnish the Black and the Metallic Gold to make the patterns more intense. With White, burnish the gold areas to make it look shiny, and create the highlight areas.

Add some Black to the cast shadow, leaving it layered so it has a grainy appearance.

polished brass

In general, it takes a shiny, burnished approach to create the look of polished brass. Because the surface of polished brass is so reflective, it is important to incorporate all of the reflections of light and color from surrounding objects.

The difference between the two drawings on this page is that the spittoon is rounded with softer edges, and the teapot is angular with harder edges. The reflective lighting on the spittoon is more gradual because of the smooth curves of its surface, while the sharp angles of the teapot drastically change the reflective lighting.

Burnish to Create Polished Brass

Burnishing is usually used to create the look of polished brass. There are many colors seen in the spittoon that come from the surrounding textures in the background, such as the wood grain of the table and the rattan texture of the chair back.

Reflections of a Brass Teapot

I love the variety of colors and textures in this still life, and the way the colors reflect off the brass teapot. The red tones of the books bounce off the right side of the pot, and the table's wood color bounces off its underside.

This piece is also full of shadows. The light source is coming from the left side, so all the shadows bounce off to the right of the objects. Study how the teapot's shadow moves across the table and up the side of the books. Before you begin to draw, always study the effects of light on your subject matter and the shadows it creates.

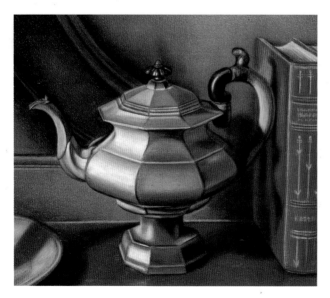

metal ornament

This metal ornament is a great beginning project because it is a simple sphere. Once you have finished this project, try it again with different colors. Try one in red, blue or your favorite color.

MATERIALS

paper
Stonehenge

colors
Canary Yellow, Light Umber, Yellow Ochre, Scarlet Lake, White

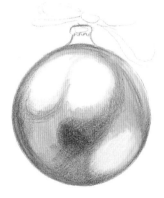

1 CREATE THE LINE DRAWING AND FILL IN THE UNDERTONE

Lightly trace a circle on your drawing paper using a mechanical pencil. Use a template or trace around a glass or other round object for accuracy. Draw in the top of the ornament and the ribbon.

Fill in the undertone of the ornament with Canary Yellow. This is the basis of the drawing's deep gold tone. Leave the bright highlight areas the white of the paper. Add the shadow edge to the lower portion of the ornament with Yellow Ochre.

2 CREATE THE SHADOW EDGES

Continue adding color to create the shadow patterns. Start with Light Umber and subtly apply it to the outside edge of the ornament. It should not look like a solid outline. Also touch up the top neck of the ornament and the hanger. Add the dark spot in the center of the ornament with Light Umber.

With Scarlet Lake, apply color along the inside edge of the ornament to create a shadow edge.

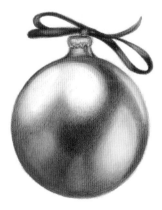

3 ADD DETAILS AND BURNISH THE COLORS

Build up the color of the ornament using the same colors as before and burnish them together. Add White to the highlight areas and burnish it to look smooth and shiny. Detail the neck and hanger. Notice how the edge of the hanger has a scalloped edge and is surrounded by reflected light. Even though it is a small area, the tiniest details are still important.

With Scarlet Lake, add some color to the ribbon. Add Light Umber to the shadows to make them three-dimensional. Add a small amount of Scarlet Lake to the very top of the hanger to create a reflection.

dull metal

Drawing dull metal is much different than drawing shiny surfaces, such as brass and silver, because it is porous and less reflective. The tones of dull objects are less extreme, and the patterns of light and dark appear more gradual than shiny objects. To achieve a dull look, use the layering technique, making sure to allow some of the paper's surface to show through.

LEE'S LESSONS

Make sure to keep a sharp point on your pencil when layering to help you fade the colors gradually.

Dull Metal Reflects Many Colors

This goblet is another antique from the Pompeii museum of artifacts. It has many of the same elements as the stainless steel pan on pages 88–89, with many raised surfaces and patterns. But unlike the pan, the goblet's surface is extremely dull. The ornamentation and raised patterns of this goblet create shadows that make for an interesting drawing. It is made of metal, but is not extremely polished and shiny—the surface almost looks pitted.

How many colors do you see reflecting in this piece? Look for different greens, oranges, grays and violets.

The layering approach is used to create the look of dull metal in the goblet on the facing page. Because of its three-dimensional quality, the five elements of shading apply to each raised area, such as the edges of the figures around the top of the goblet. Practice drawing the comma-shaped patterns from the middle of the goblet.

MATERIALS

paper
Stonehenge

colors
Sienna Brown, Greyed Lavender, Non-Photo Blue, Ultramarine Blue, Black

1 CREATE THE LINE DRAWING AND LAYER THE UNDERTONES

Use Black to sketch in the basic shapes, or the recessed areas of the goblet's decoration.

To create the subtle colors and textures, use the layering approach and a small amount of Greyed Lavender for the undertone. Add a touch of Sienna Brown using a very sharp point. This will help the paper texture show through.

2 DEEPEN THE TONES

Add a bit more Greyed Lavender along the rim, and some Sienna Brown to the edges of the motif. Add some blue tones with Non-Photo Blue in the upper area and Ultramarine Blue along the bottom edge.

3 FINISH THE DRAWING

Deepen the shadow areas by layering Black over the colors previously applied. Make these areas deep in tone, but do not allow the black to burnish. It is important that the paper texture shows through.

THINGS TO REMEMBER

- Drawing a metallic surface is very much like drawing glass.
- A dark background is very important with shiny, polished brass because it helps the light edges of the object stand out.
- Don't just use black and white when drawing stainless steel or silver. Colors make the drawing more realistic.
- When drawing polished brass, be sure to incorporate all the reflections and colors from the objects surrounding it.
- Even the tiniest details are important, especially when drawing reflective metal.
- Unlike polished metal, drawing dull metal requires the layering approach to achieve the less extreme tones and the porous look of full metal. To enhance this look, allow the paper's texture to show through the colors.

8 Nature

Nature gives us a wonderful array of things to draw. Skies, water, sunsets and flowers—simply look out your window for unending inspiration!

Suede board is a wonderful drawing surface for nature scenes and flowers. It creates a pastel-like quality to the subject and makes sky tones and flower petals appear soft and smooth. Even though suede board is soft, it is still possible to use firm pressure to create distinct edges and overlaps, which are important when drawing natural subjects.

Study of Red Rose Against Green
Light gray suede board
11" × 14" (28cm × 36cm)

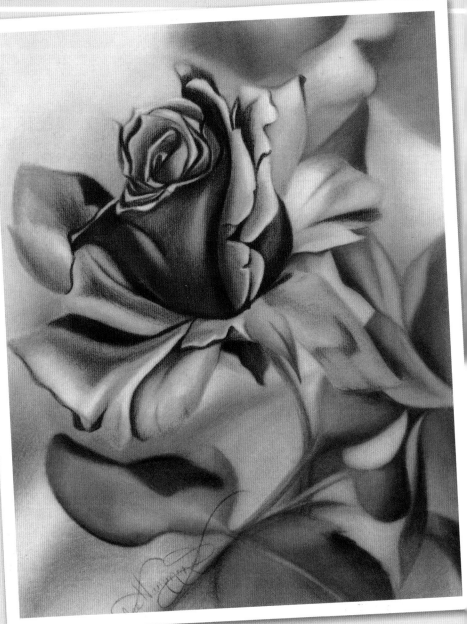

Experiment With Complementary Colors in Flower Scenes

This red rose, drawn on light gray suede board, takes on a soft, diffused look, and the background appears to be out of focus. This is a good example of a complementary color scheme—red against green. This color scheme is repeated often in drawings of flowers and nature.

Flowers are a very popular subject for colored pencil artists not only because of their beautiful colors, but because they are made up of a multitude of shapes.

Colors Used
Hot Pink, Process Red, Crimson Red, Poppy Red, Scarlet Lake, Magenta, Dark Purple, Apple Green, Grass Green, True Green, Dark Green, Peacock Green, True Blue, Black, White

flower basics

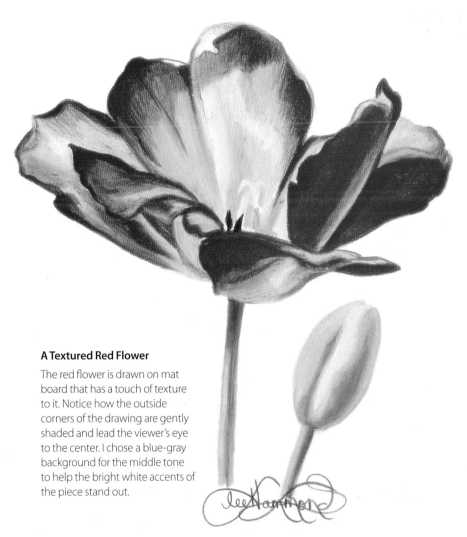

Flowers are a fun and interesting drawing subject because there are so many colorful varieties. When observing flowers to draw, keep in mind the many overlapping petals that create hard edges of reflected light and cast shadows.

Flowers also have many different textures. To achieve depth and realism, it is best to use the layering technique to draw dull, fuzzy surfaces, and to use the burnishing technique to draw shiny, reflective petals.

A Textured Red Flower

The red flower is drawn on mat board that has a touch of texture to it. Notice how the outside corners of the drawing are gently shaded and lead the viewer's eye to the center. I chose a blue-gray background for the middle tone to help the bright white accents of the piece stand out.

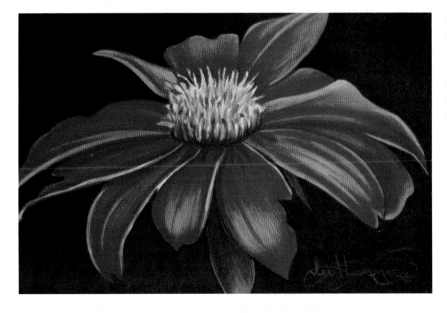

Create a Dramatic Look With a Black Background

For a dramatic look, fill the entire background with black, like the exercise of the pink daisy on pages 96–97. The colors of this zinnia look very intense against the dark background.

pink daisy

MATERIALS

paper
Stonehenge

colors
Magenta, Hot Pink, Process Red, Canary Yellow, Limepeel, Black

This flower has a lot of overlapping petals and an extreme light source. This combination creates many extremes of light and dark tones and shadows. The grid method for capturing shapes is really handy when drawing flowers and helps to capture the tiny details.

Reference Photo

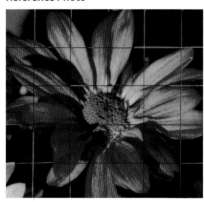

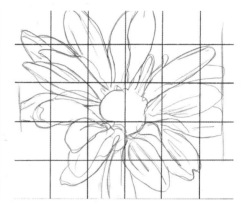

1 CREATE THE LINE DRAWING
Use the grid to create a line drawing with a mechanical pencil. When your drawing is accurate, erase the gridlines with a kneaded eraser.

2 OUTLINE THE EDGES AND BEGIN THE SHADOWS
Fill in the center of the flower with Canary Yellow using circular pencil strokes. Once the Canary Yellow layer is complete, overlap it with Limepeel on the upper side of the flower's center. Along the left side, overlap the Canary Yellow with Magenta. This will accentuate the center of the flower.

With Magenta, begin outlining the petals. Look for areas that are extremely dark and areas that are lighter, and use thinner lines and less pressure in the light areas. Lightly fill in some of the shadow areas with Magenta to begin the look of overlapping petals.

3 BUILD THE TONES

Continue building the tones of the flower. Add more creases to the petals with Magenta and fill the lower sides of the petals with Hot Pink. Use Process Red to layer the left sides of each petal's shadows.

With Black, add some small circles to the flower's center. Use a light touch—you don't want the circles too dark. Also use the Black to create the shadows along the edges of the flower's center. Follow the patterns carefully, paying close attention to how the edges weave under some of the petals.

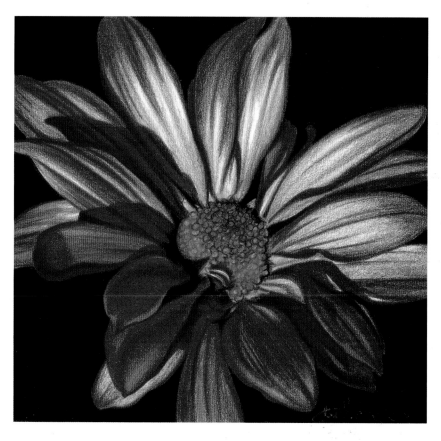

4 DEEPEN THE TONES AND FILL IN THE BACKGROUND

Finish the drawing by building up the Magenta, Hot Pink and Process Red. Allow some of the white of the paper to show through to give the petals a streaked appearance.

You can leave the paper white if you like, or choose to fill in the background with a solid application of color. A black background really makes the flower stand out, but any color will work.

lily on suede board

MATERIALS

paper
White suede board

colors
Canary Yellow, Parrot Green, Peacock Green, Dark Green, Chartreuse, Light Green, Spring Green, Yellow Chartreuse, Orange, Crimson Red, Tuscan Red, Black

Practice drawing a flower against a completed background. I cropped the photo to focus on just one of the flowers, and to eliminate some of the unnecessary subject matter. Create the drawing in the size you want the piece to be, and use transfer paper to place the line drawing to the suede board. Once the drawing is transferred to the board, you can clean up any smudges with a kneaded eraser. Do not use any other type of eraser, because it will damage the surface of the paper.

Reference Photo

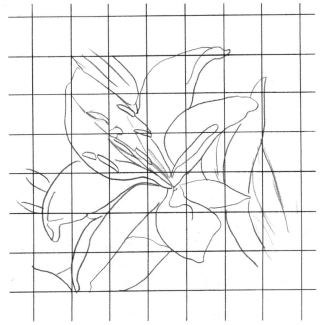

1 TRANSFER THE DRAWING ONTO SUEDE BOARD
Use the grid method to capture this flower on regular drawing paper. It is not possible to use the grid method on suede board, so the line drawing must first be created on a regular piece of drawing paper and then transferred using transfer paper. (See Lee's Lessons on the facing page for instructions.)

2 BEGIN ADDING THE UNDERTONES AND THE BACKGROUND
Once you have successfully transferred the line drawing to the suede board, begin adding Canary Yellow to the flower petals and flower pods.

Begin adding the background color to create the edges of the flower. Use Parrot Green for the overall background tone, Spring Green for the leaf areas and Light Green for the pale leaves on the right side. At this point, all the undertones of the drawing should be placed on the suede board like a colored road map.

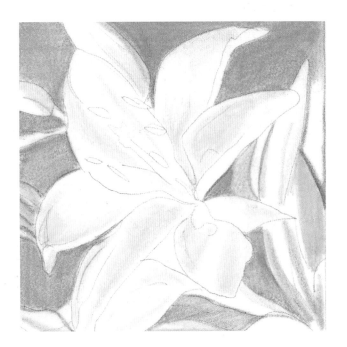

3 DEEPEN THE TONES

Continue adding color to the flower by overlapping the Canary Yellow with Orange. Use the Orange to outline the edges and ridges of the flower where it bends and curves.

Deepen the tones of the background with Peacock Green, which is mostly in the shadows. Use Dark Green and Black for the darkest green tones. Study the patterns of color closely in the finished example.

Add some Yellow Chartreuse to the brightly colored leaves and flower pods.

4 FINISH THE DRAWING

Add Crimson Red to the flower in the recessed areas in the center. Use the Crimson Red to create some of the crisp edges and the striations within the petals. With Tuscan Red, fill in the stamens and use Black for their edges. Use Tuscan Red to outline the edges of the petals in the center.

Continue deepening the colors of the background. Layer some Black over the Peacock Green in the upper right corner to create the illusion of depth. Develop the patterns and colors until your drawing comes to life.

THINGS TO REMEMBER

- Complementary color schemes make flowers pop on the page.
- Use the grid method when drawing flowers to help capture tiny details.
- Only use kneaded erasers on suede board—others will damage the surface of the paper.
- Consider drawing flowers on suede board for a softer, smoother appearance.

LEE'S LESSONS

Transfer paper can be found in any arts and crafts store. Sketch your line drawing on the back side of the transfer paper with a soft graphite pencil. Carefully place the paper, graphite side down, over the suede board. Outline the image with a regular pencil and the graphite underneath will transfer to the suede board.

Once the drawing is transferred, clean up any smudges with a kneaded eraser. Do not use any other type of eraser, because it will damage the surface of the paper.

water surfaces

Whenever you are drawing an object surrounded by water, you must include the reflections in the water. Unlike shadows, which change depending on the light source, reflections are always vertical and directly below the object. When drawing reflections, remember that the movement of the water interrupts the image and somewhat distorts the shapes.

Water Reflections Are Always Vertical

This is a drawing of my grandson, Gavyn, at the beach. Study all of the colors reflecting below him in the sand—such reflections are always vertical and are never as bright as the original subject matter.

Colors Used

Peach, Henna, Dark Brown, Light Umber, Goldenrod, Tuscan Red, Greyed Lavender, True Blue, Grass Green, True Green, Light Aqua

A Wood Duck on a Still Pond

This drawing of a wood duck shows the extreme reflections water can create. Although the water was very still when I took this photo, the shape of the duck's head is distorted and appears larger in the reflection. The colors are still quite stark, but they are not as bright as the actual duck.

Colors Used

Poppy Red, Sand, Terra Cotta, Bronze, Peacock Blue, Parrot Green, Tuscan Red, Olive Green, Periwinkle, Mediterranean Blue, Black, White

water droplets are spheres

To draw water droplets, you'll combine what you know about spheres and glass. Each droplet reflects its surroundings just like a glass surface. Study different photos of water droplets and observe the different variations. After some practice, you will be able to add them to your artwork from memory.

A Droplet Is Raised From Its Surface

This is a close-up of the pears from page 42. View each droplet of water as a separate sphere, complete with its own highlights and cast shadows.

Colors Used

Lemon Yellow, Apple Green, Grass Green, Dark Green, Crimson Red, Tuscan Red, Dark Brown, Black, White

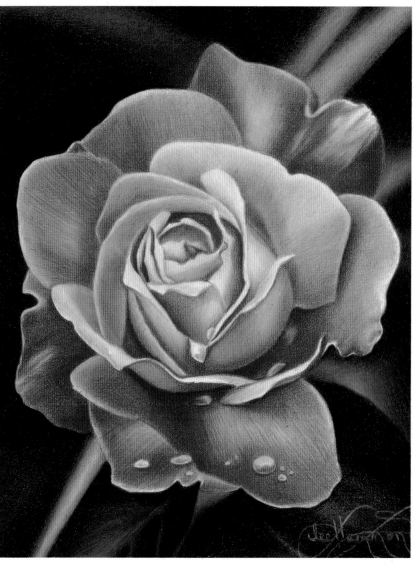

Water Droplets Reflect the Color of a Surface

Although water appears clear in color, it always reflects the color of the surface it lies on, like the pink of this rose.

Colors Used

Light Peach, Pink Rose, Hot Pink, Process Red, Scarlet Red, Mulberry, Apple Green, Limepeel, Grass Green, Dark Green, Black, White

water droplets

This is an exercise of the water droplets on the rose on page 101. Notice that it is the pink color of the petals that creates the tone of the droplets. Practice drawing droplets of different sizes, shapes and colors. Adjust the light source to affect each drawing, and remember that there may be multiple highlights within each drop.

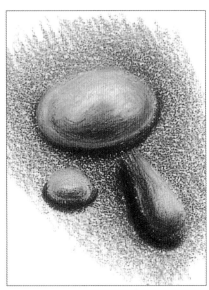

1 SKETCH THE LINE DRAWING
Lightly draw the shape of the droplets with a mechanical pencil. They should closely resemble a sphere, and could vary in shape from oval to teardrop. Add some Hot Pink around the droplets to represent the flower petal. With Pink and a sharp point, begin shading the lower edges of the droplets.

2 BUILD THE TONES
Apply the lightest color, Hot Pink, to the top edges of the droplets. With a medium color, Pink, add a shadow edge inside the droplets. Then with the darkest color, Mulberry, add a cast shadow below the droplets, making sure to leave a little white of the paper showing through for highlights.

3 BURNISH THE COLORS
Build each of the tones a bit more, then burnish the colors together with White to make them smooth. Take the White and lighten the reflected light directly above the dark line of the cast shadow around the bottom edge of the droplet. Then, add the bright highlights on top.

Now that you're comfortable drawing droplets by themselves, practice them on a surface. Here, the dark greens of the leaf help the water stand out. Focus on the dark and light contrasts when capturing wet subjects in colored pencil.

MATERIALS

paper

Stonehenge

colors

Grass Green, Dark Green, Tuscan Red, White

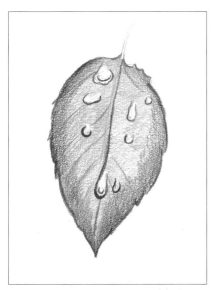
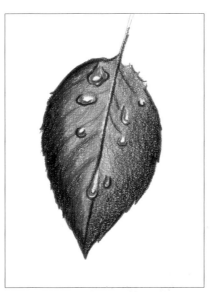
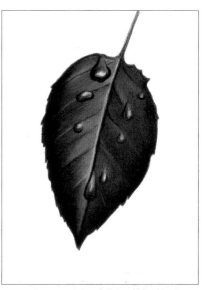

1 SKETCH THE LINE DRAWING
Lightly sketch in the shape of the leaf with a mechanical pencil. Draw in the water droplets—note that they are each a different shape.

Lightly fill in the leaf with an even application of Grass Green. Make sure to leave the droplets the white of the paper.

With Tuscan Red, apply the veins and edges of the leaf with a sharp point. Lightly layer this color to the outside edges of the leaf. With a sharp point and firm pressure, draw a distinct line of Tuscan Red underneath each water droplet to create their cast shadows. Also apply a shadowed edge to the leaf's top and bottom droplets.

2 DEEPEN THE TONES
Deepen the tones of the leaf using the same colors, also layering Dark Green to the left side of the leaf. With Grass Green, add shadow edges to the water droplets. Continue to leave the white of the paper exposed around the edges of the drops and their highlight areas. There is a light area down the left side of the center vein that needs to remain white as well.

3 FINISH THE DRAWING
Finish the leaf and the droplets by burnishing each of the colors. The droplets are brought to life by burnishing the highlights with White to make them shine. You can clearly see the sphere exercise practiced in each one.

water and waves

MATERIALS

paper
Stonehenge

colors
Canary Yellow, Orange, Yellow Orange, Tuscan Red, Celadon Green, Black, White

This is a drawing of a photo I took in Puerto Vallarta, Mexico. This particular shot captured the last few moments of daylight. The sun's deep rays bounced magnificently off the water, creating many light and dark patterns. Drawing water is similar to drawing clouds, because they both move horizontally. Follow along and learn how to capture the look of water and waves.

1 CREATE THE LINE DRAWING AND PLACE THE UNDERTONES

With a mechanical pencil, lightly apply the horizon line, where the water and sky meet, about a third of the way down your paper. Draw a very light circle where the sun will be, and lightly sketch in the main waves.

Using the layered approach, apply Canary Yellow evenly across the top of the horizon, making sure there are no noticeable pencil lines. Do not go over the pencil drawing of the circle that represents the sun. The graphite will darken and you will not be able to erase it. Place Canary Yellow all around the circle, then remove the graphite with your kneaded eraser, creating the white spot. Add Canary Yellow all the way into the water directly under the sun. This is where the sunlight reflection will be.

With Yellow Orange, fill in the small mountain on the left. With Orange and a light touch, fill in the water area on both sides of the reflection. Add the main waves with Tuscan Red.

2 BUILD THE TONES OF THE SKY, SAND AND SUN

Continue building the color of the sky with the layered approach, taking care to disguise any pencil lines. Deepen the color with Canary Yellow, and make the color around the sun extra deep so that it looks bright white.

Deepen the sky with Yellow Orange, moving out from the sun. With Orange, continue out even farther. Create the sun rays by lifting them out with the kneaded eraser in a wagon-wheel pattern. Don't worry if you lift too much, you can add the color back in with Canary Yellow.

Use Celadon Green to depict the subtle hint of the blue sky showing in the upper corners. The yellow of the sun mixes with the blue of the sky to produce a green cast.

Deepen the colors of the yellow water reflection with Canary Yellow and Yellow Orange. Create the shoreline with Orange. Add the deep red colors to the mountaintop, the waves, and the shoreline with Tuscan Red. Allow the Canary Yellow to show along the base of the mountain to create a hazy effect.

3 DEEPEN THE WAVES AND FINISH THE DRAWING

Deepen the colors and patterns of the drawing by building all up the previous colors. Use Black to create the illusion of ripples and waves using pencil strokes that mimic the movement of water. In the distance, closer to the horizon line, the lines are straighter across and close together. As the waves get closer to the foreground, the patterns become more arched and pronounced. Go back and forth with the pencil lines to help create the patterns of water. Reapply the lighter colors of Canary Yellow and Orange until you are happy with the way it looks.

In the outer edges, of the drawing add some Celadon Green to the water to represent the reflection of the blue sky tint.

Deepen the color of the sand with more Orange and Tuscan Red. With White, fill in the sun and soften its outer edges. Add a touch of White into the brightest highlight areas of the water.

realistic water reflections

MATERIALS

paper
Stonehenge

colors
Grass Green, Apple Green, Limepeel, Dark Green, Canary Yellow, Orange, Non-Photo Blue, Greyed Lavender, Black, White

This drawing of a duck will give you experience drawing mirror images reflecting in water. The ripples here help the drawing appear more natural than the duck drawing from page 100.

Reference Photo

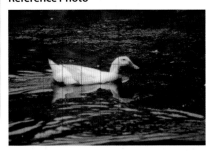

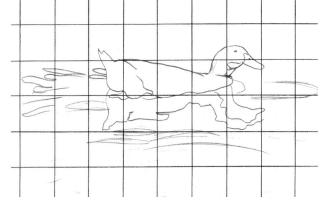

1 CREATE THE LINE DRAWING
Using the reference photo and a mechanical pencil, create an accurate line drawing of the duck. Remove the grid lines with a kneaded eraser.

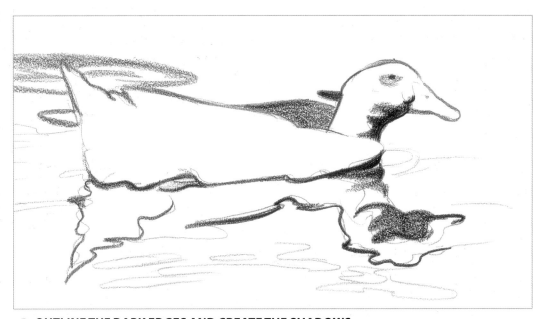

2 OUTLINE THE DARK EDGES AND CREATE THE SHADOWS
Begin applying Black to the drawing once the grid has been removed. Because the duck is white, it is important to create the edges and shadows of the duck first so it doesn't get lost. Notice how the shadow of the neck is repeated in the water. The movement of the water distorts the shapes, giving them a wavy appearance.

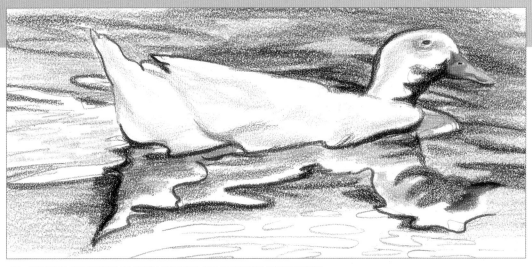

3 BUILD THE WATER AND BEGIN DRAWING THE DUCK

Identify the ripples of the water and draw them in with Black. Begin filling in the water with Grass Green. Leave the area directly behind, below and in front of the duck the white of the paper. Add Non-Photo Blue into the duck's wake.

Use Greyed Lavender to create the form of the duck. Make sure not to pull the Greyed Lavender all the way out to the edges where the reflected light shines.

Base in the bill of the duck with Canary Yellow. Apply Orange over it, allowing the reflected light to remain along the bottom. Add some Orange to the water area under the duck to represent the bill's reflection, the leg and the foot.

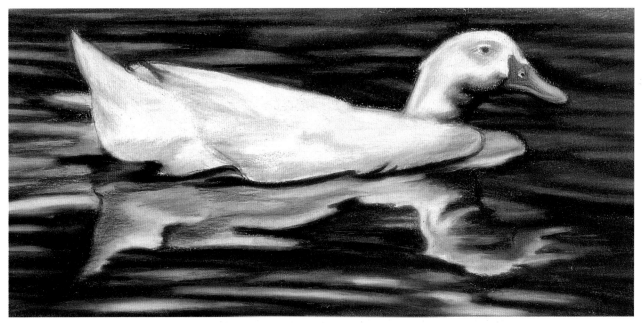

4 BUILD AND BURNISH THE COLORS

Finish the drawing by building up the colors until they burnish together. Create the patterns of the water's ripples by drawing elliptical shapes that mimic the movement of the water. In the water, use four different shades of green—Limepeel, Apple Green, Grass Green and Dark Green—using the lightest tone at the top of the drawing.

Add White to the reflections and streaks of Non-Photo Blue. Add White to the duck's highlighted areas and soften the Greyed Lavender and shadows. Using Black, continue to deepen the ripples of the water. Use elliptical shapes to create the illusion of water movement.

skies and clouds

Skies and clouds are one of the most beautiful things to draw. You can use a variety of approaches when creating skies and clouds because each one is different. Thick, white clouds can be burnished to make them appear light and fluffy, and wispy clouds can be layered to help them fade into the sky, especially if they are darker in color than the sky. Here are some examples that show you the different techniques for skies and clouds.

Clouds Add Depth to Any Drawing

Clouds are like snowflakes—no two are alike. Burnishing is what makes clouds look fluffy and dimensional. The subtle tonal changes give them depth. I love the colors and shapes they create. This little drawing has a lot of depth because of the colors and the layers of the clouds. Although it is all in blue tones, it is very rich in hue. You can create the same drawing and turn it into an entirely different look by simply adding or changing colors. You could also take this and use it as a background, adding some trees in the foreground. Or you could add a horizon line and create a lake or ocean below it.

Colos Used

Sky Blue Light, True Blue, Cloud Blue, Imperial Violet, Ultramarine Blue, White

LEE'S LESSONS

Clouds and atmosphere always move side to side, not up and down. All pencil lines associated with a sky should be placed horizontally. Always study your subject or reference photo and note the direction of the sunlight. In the example at right, the sunshine is centrally located and peeks through the clouds a little off center and to the right. It streaks through the sky in a horizontal fashion.

Create a Subtle Sunset With Complementary Colors

This example shows what can be done with very few colors and the layering approach. Layering gives the drawing a gentle appearance, while the use of opposite colors adds punch. Study your reference photos carefully before you begin to draw, so you know which technique is required to obtain the look you want.

Use the White of the Paper to Create Rays of Light

This sky is a beautiful example of how intense the sky can be when drawn in colored pencil. Use the white of the paper to create contrast with bright, sunlit areas. See how the rays of light overlap the dark clouds below? Burnish the colors surrounding the white paper to create this intense separation.

This drawing is dedicated to my dear friend, Kelly McBride.

Rays of Hope
Stonehenge paper
8" × 10" (20cm × 25cm)

colorful sunset

MATERIALS

paper
Stonehenge

colors
Lemon Yellow, Peach, Lavender, Sky Blue Light, China Blue, Parma Violet, Black

When you draw an entire scene, you must work from back to front. In this landscape, objects in the foreground overlap the things in the distance. In this piece, we will start with the sky and all the great colors in it.

1 LOCATE THE HORIZON AND CREATE THE LINE DRAWING

Locate the horizon line, or where the sky and the water meet. In this piece, the horizon line is low, about one fifth of the way up from the bottom of the composition. Lightly draw a line across the paper, parallel to the lower edge, and lightly sketch in the palm trees.

Begin by placing in the sunshine streaks with Lemon Yellow, noting the direction of the sunlight and rays. Add some Lemon Yellow to the water area below the horizon line.

Apply Peach to the water to the left side of the Lemon Yellow. Add it across the sky, and around the Lemon Yellow. Place Lavender and Parma Violet in horizontal patches throughout the orange sky tones.

Use China Blue and to create the deep blue tones along the horizon line that separate the ocean and the sky. Create the lighter colors in the water with Sky Blue Light.

2 DEEPEN THE TONES

Repeat the previous steps using a firm pressure so the colors burnish together. Do you see how much smoother and creamier the colors look in this version as opposed to the layered tones of step 1?

110

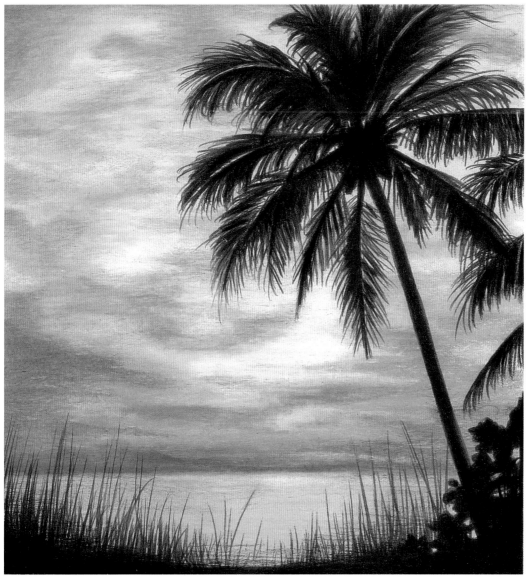

3 ADD THE FOREGROUND DETAILS

Use your mechanical pencil to lightly sketch in the foreground shapes to use as a guide. Fill in the largest shapes first, such as the trunk of the tree and the shoreline. With Black and a very sharp point on your pencil, apply the palm leaves, the small bush to the right of the tree, and the blades of grass. If you haven't drawn a palm tree before, I would suggest practicing first on a separate sheet of paper.

Notice how the individual palms pull out from the center, resembling a feather and a quill. The tapered ends must be applied with quick strokes. The same is true for the grass. Be sure to use quick strokes, lifting your pencil at the end so the width of the line becomes very thin.

Apply the Black as dark as possible with firm pressure. Because this is a silhouette, no small details of the foreground should be visible.

snowy landscape on suede board

MATERIALS

paper
White suede board

colors
True Blue, Ultramarine Blue, Goldenrod, White, Black

In this landscape, the smooth finish of suede board adds to the softness and realism of the colors. The fuzziness of the paper diffuses the colors, creating a pastel-like finish.

Remember that you cannot draw a full grid on suede board. To get started, lightly sketch in a few guidelines to indicate the horizon line and basic background elements.

Reference Photo

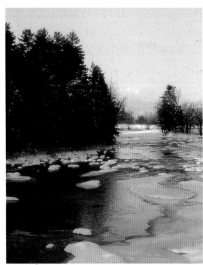

1 LIGHTLY SKETCH THE GUIDELINES

Lightly draw the horizon line on suede board about a third of the way down using a blue colored pencil. Lightly sketch an outline of the riverbank, the trees and some of the ice patterns in the water.

2 LAYER THE CLOUDS AND BASE IN THE RIVER

Create the clouds in the background using True Blue and horizontal strokes. With Goldenrod, apply some color to the trees in the background. Loosely apply the pencil to the suede board so no texture or real shape is created—only an undertone.

Fill in the river with Ultramarine Blue. Use a light pressure so the pencil lines do not show and the color is applied more evenly.

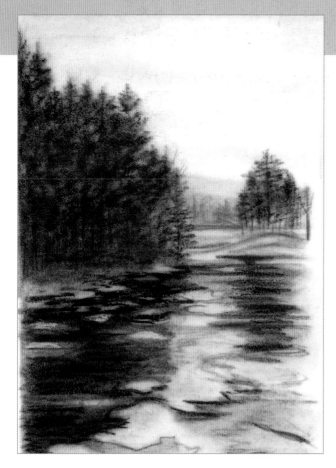

3 CREATE THE TREES AND MOUNTAINS

With Black, create the illusion of texture in the pine trees, using vertical pencil lines to represent the tree trunks. Use the flat side of pencil to create the texture of the trees using horizontal motions.

With True Blue and a light touch, add the small mountain in the far background along the horizon line. With the same color, accent the color in the water on the right. Define the bottoms of the ice flows with Black.

4 DEEPEN THE TONES IN THE BACKGROUND AND FOREGROUND

Deepen the blue tones, but allow the ice flows to stay light in color. Apply a layer of Black over the colors in the water on the left side of the river. Apply a layer of Black over the trees as well.

Use White to create the ice flows. Notice how they appear smaller and closer together in the background, and larger and more distinct in the foreground. Use True Blue to create the streaky shadows of the ice flows in the foreground.

THINGS TO REMEMBER

- Burnishing is what makes clouds appear fluffy and three-dimensional.
- Water droplets always reflect the color of the surface they lie on.
- Focus on the light and dark contrasts when capturing wet subjects in colored pencil.
- Reflections are always vertical and directly below an object.
- The movement of water interrupts an image and somewhat distorts its shape in reflection.
- Reflections are never as bright as the original subject.
- Drawing elliptical shapes creates the illusion of water movement.
- When drawing an entire scene, work from back to front to account for objects overlapping.
- Clouds and atmosphere always move side to side, so all pencil lines associated with them should be horizontal.
- The fuzziness of suede board diffuses the colors in a drawing, creating a soft, pastel-like finish.

Animals

Penny in the Summer
Stonehenge paper
11" × 14" (28cm × 36cm)

Animals and pets are some of the most popular subjects for drawing and painting in our culture. And many of us have enough reference photos of our past and present pets to create endless drawing possibilities.

Use what you've learned about texture, layering and burnishing to capture your favorite animals in colored pencil.

Combine Many Drawing Techniques to Create Furry Animals

What I like about this drawing of my dog Penny is the contrast of colors, textures and many light and dark patterns. Because Penny is outdoors, the sunlight creates deep shadows around her body.

The reddish hue of Penny's fur is complemented by the green of the grass. Since green and red are opposites on the color wheel, pairing them creates a stark contrast. To create the texture of the grass, I used many shades of green and quick, vertical strokes.

Colors Used

Cream, Jasmine, Sand, Yellow Ochre, Canary Yellow, Burnt Ochre, Sienna Brown, Terra Cotta, Dark Brown, Dark Umber, Blush Pink, Hot Pink, Poppy Red, Apple Green, Grass Green, Dark Green, Parrot Green, Cool Grey 50%, Black, White

drawing fur

The key to drawing realistic fur is to render it in multiple layers. Animal fur, no matter what type, is quite dense. To make it look believable, you must build it up, layer after layer, using many pencil strokes. Whether the fur is short or long, always pull your strokes the direction the fur is going.

Draw Dark Subjects in Reverse on Dark Paper

This is an example of a dark subject drawn on black Artagain paper. Because black tones are actually reflections of many surrounding colors, the dark fur of the cocker spaniel is still noticeable against the dark background. The dog's face is created by the illuminated highlights and contrasted color along the edges of its body.

Colors Used

Yellow Ochre, Burnt Ochre, Terra Cotta, Dark Brown, Black, White

Many Colors Reflect Off Black and White Colors

This is a drawing of my little twin dogs, Poppy and Peaches. Notice how much color from the outdoors is reflected off their black fur. Look closely and you can see greens, blues and lavenders in the color of their fur.

Colors Used

Yellow Ochre, Burnt Ochre, Terra Cotta, Dark Brown, Cool Grey 50%, Cloud Blue, Blue Slate, Lime-peel, Peach, Scarlet Lake, Black, White

an adorable puppy

MATERIALS

paper
Stonehenge

colors
Dark Brown, Cool Grey 50%,
Goldenrod, Terra Cotta,
Sienna Brown, Pink Rose,
Black, Cloud Blue

This is a simple exercise that will give you valuable practice drawing animals. To create this precious King Charles Spaniel puppy, it doesn't take many colors because it uses a lot of white from the paper.

Reference Photo

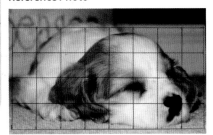

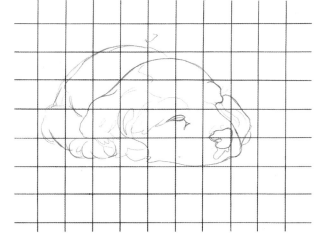

1 SKETCH THE LINE DRAWING
Sketch a line drawing of the puppy's figure using the graphing method. Check for accuracy, then carefully remove the grid lines from your drawing with a kneaded eraser.

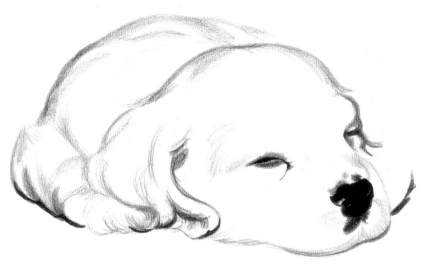

2 BEGIN ADDING COLOR
Fill in the nose with Black and allow the small areas of reflected light around the nostrils to remain the white of the paper. Draw the slits of the eyes and place small shadows under the leg, under and inside the ear and under the muzzle. Add Dark Brown along the outside edges of the puppy. Use Cool Grey 50% around the lip area below the nose and the on the small spots above it. Add some Dark Brown around the eye, leaving a small edge of reflected light.

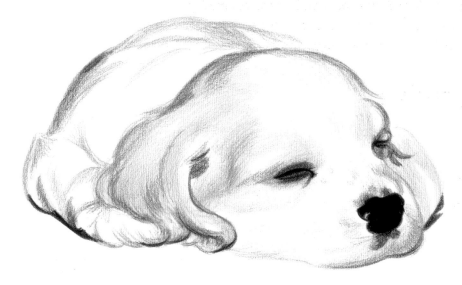

3 FILL IN COLOR AND ADD SHADOWS

Lightly place some Pink Rose around the eye and around the muzzle. Fill in the ears with Goldenrod. Also use the Goldenrod to go around and above the eyes. Using Cool Grey 50%, add shadows along the rear of the puppy and along the front leg and paw. Add some Black under the ear on the right.

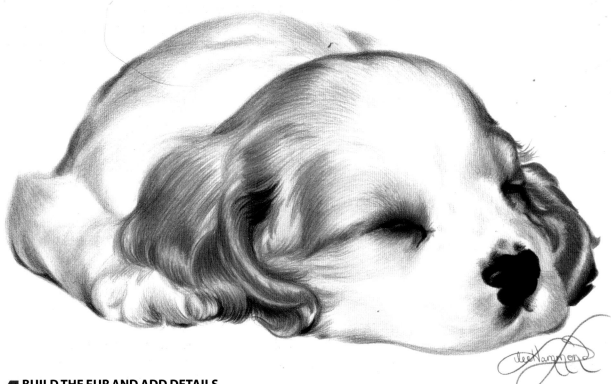

4 BUILD THE FUR AND ADD DETAILS

Add Sienna Brown and Terra Cotta to build the fur color. At this stage in your drawing, the pencil lines must follow the direction that the fur flows to create texture. Add more Pink Rose around the eye.

As you draw, notice where the fur reflects light and leave those areas exposed, showing the Goldenrod color. Add Cloud Blue where light is reflected on the puppy's back and legs to create form and dimension. This color brings the drawing together, giving it a finished element of realism.

white cat

MATERIALS

paper
Stonehenge

colors
Greyed Lavender, Seashell Pink, Black Raspberry, Cloud Blue, Cool Grey 30%, Limepeel, Black, White

Nubby, my white Manx, is one of my favorite drawing subjects. (Mostly because he is so lazy and easy to photograph!) Although he appears white, you can see in the reference photo that many colors are reflecting off his fur.

Reference Photo

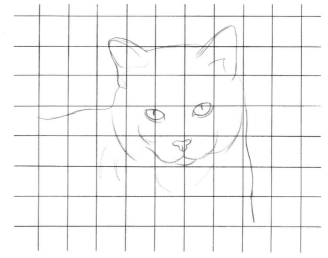

1 CREATE AN ACCURATE LINE DRAWING
Use the grid method to obtain an accurate line drawing. When you are satisfied with your drawing, carefully remove the grid lines with your kneaded eraser.

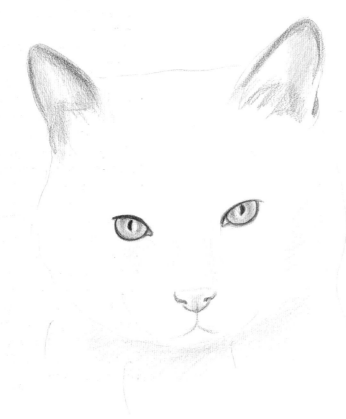

2 BEGIN THE EYES AND NOSE
With Black, apply a light outline around the edges of the eyes and fill in the pupils. Lightly layer the iris with Limepeel. Leave a small area of paper exposed for the catchlight, as well as a slight rim of reflected light around the outside of the pupils and outer edges of the irises.

With White, burnish the catchlight of the eye to make it appear reflective. Lightly layer the Limepeel with Dark Brown to make the eyes appear round and lifelike.

Add the inner color of the ears with Seashell Pink. Darken the outer edges of the ears with a light application of Black. Add a small amount of Seashell Pink to the tip and rim of the nose, and under the chin. Use this color to begin the shadow areas along the right side of the nose and face.

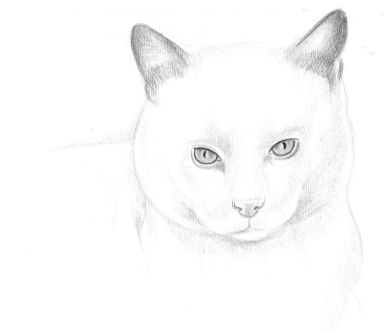

3 DARKEN THE TONES

With Black Raspberry, darken the tones of the inside edge of the ears and the lower rim of the eyes. Add some Seashell Pink to the top of the head and a small amount above the eye on the left. Use this color to deepen the nose tones.

Apply Cool Grey 30% to the face contours and shadows—the darkest areas of the drawing. Use this color to create the body's outline and shade the main body shapes. Don't worry about getting too detailed; you will layer the background around the body using the white of the paper in the next step.

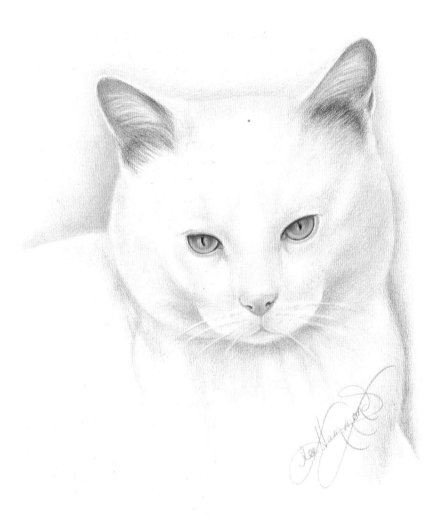

4 DARKEN THE TONES AND FINISH THE BACKGROUND

With a sharp point, layer the facial contours and shadows with Greyed Lavender, then lightly overlap them with Cool Grey 30%. Do you notice the warm tone of the areas where the colors overlap? Continue layering the Greyed Lavender down the chest and along the right side of the body.

Darken the nose with Seashell Pink and add a hint of Black Raspberry to the middle area. Make sure to leave a rim of reflected light around the nostrils.

Using a craft knife, lightly scratch out the whiskers and hairs inside the ears. Be careful not to gauge the paper! Fill them in with White, using long, quick strokes to create a tapered look. If you make the lines too thick, narrow either of their sides with Cool Grey 30%. Use this color to add a few hairs in the ears and create the pores on the cat's muzzle.

Finish the background with a light layer of Cool Grey 30% along the edges. With a sharp point, gradually overlap the Cool Grey 30% with Cloud Blue to define the edges of the cat.

bengal tiger

MATERIALS

paper
White suede board

colors
Light Cerulean Blue, Dark Brown, Black Raspberry, Cloud Blue, Black, White

Drawing an animal on suede board can give fur a smooth, realistic appearance. This white tiger is perfect for this technique, and the finished result is soft and beautiful. The way colors bounce off the white fur is very similar to the drawing of Nubby on pages 118–119.

Reference Photo

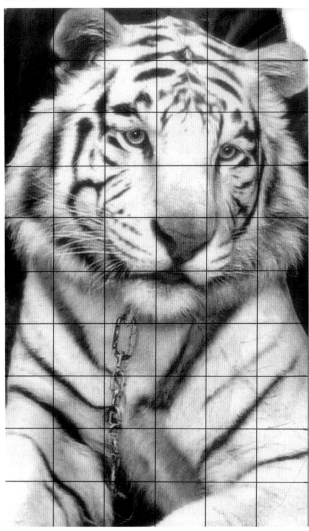

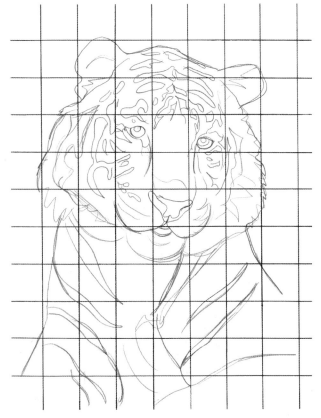

1 TRANSFER THE LINE DRAWING TO THE SUEDE BOARD

Use this drawing as a guide to transfer your line drawing to the suede board (see page 99 for more detailed instruction on transferring). Clean up any smudges with a kneaded eraser. Do not use any other type of eraser because it will permanently smudge the graphite on the suede board.

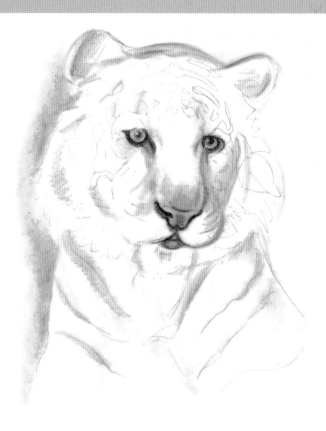

2 BUILD THE FACIAL TONES AND BACKGROUND

With Dark Brown, carefully and lightly apply the tones to the top of the head, around the eyes and down the sides of the nose. Continue adding the Dark Brown to the top of the nose and into the striped areas of the body.

Fill in the pupil and outline the outer edge around the eyes with Black. Use Light Cerulean Blue to fill in the eye color. Layer it more heavily around the pupil, and lighter as you work toward the outer edges.

Use Black Raspberry to gently fill in the nose. Use a firmer pressure to deepen the edges and middle of the nose. Use this color to create the lips, adding a little bit below the mouth onto the chin. Use Black to outline the nose and create the nostril area. Also use Black to edge the lips and mouth area.

Add realism and warmth to the Dark Brown of the tiger's features by using Black Raspberry to render the corners of the eyes and side of the nose. Add Black Raspberry to the inside of the ears as well.

Using Cloud Blue, create the three-dimensional form and the illusion of soft shadows along the tiger's back, chest and face. Place the Cloud Blue around the tiger to help create the soft edges. Adding this color here also makes its beautiful blue eyes stand out.

3 BEGIN THE STRIPES AND DEEPEN THE BACKGROUND

With Black, begin adding the stripes of the tiger, following the patterns in the line drawing. Add some Black to the insides of the ears, but don't fill them in completely. Use the Black to deepen the outlines of the mouth area.

Continue adding Light Cerulean Blue to the background around the tiger, working the color toward the suede board's edge. Deepen the tones on the right side of the tiger by adding some Black over the Light Cerulean Blue. Allow it to fade out gradually with a light touch.

4 DEEPEN THE TONES AND FINISH THE BACKGROUND

Deepen the tones throughout the drawing. Using Black and a very light touch, create more shadow effects on the tiger by adding various gray tones around the sides of the face and in the body. To soften these shadow areas, overlap the gray areas with Light Cerulean Blue.

Finish the background by adding more layers of Light Cerulean Blue. Deepen the color directly around the tiger, and allow it to fade out toward the suede board's edge. Soften the darker left side by overlapping the Black with Light Cerulean Blue.

Continue to deepen the tiger's stripes with Black. Do not outline each stripe. They must look natural and soft on the edges. In the stripes around the edges of the face, use quick strokes, overlapping the white areas. This will render the appearance of individual furs on the face.

To finish the drawing, add white whiskers and small hairs with a White pencil. It is important to have a sharp point, but also to use firm, quick strokes. Make sure to taper the pencil lines at the end to create the realistic look of animal hair. It looks unnatural when a pencil line is the same width from beginning to end.

With White, add the whiskers and the hairs inside the ears. Add some White strokes to the outside edges of the tiger, overlapping the background. With White, add some small dots into the chin area for texture. Finally, add some White to the highlights in the eyes to make them shine.

horse in motion *demonstration*

This is a beautiful photograph of a horse in motion. The mane blowing in the wind gives the horse an elegant look and the viewer a feeling of action. The extreme contrasts also give the drawing a lot of visual impact. The drawing's intense lights and darks as well as deep shadows are achieved by an exaggerated light source.

MATERIALS

paper
Stonehenge

colors
Orange, Terra Cotta, Dark Umber, Tuscan Red, Non-Photo Blue, True Blue, Black

Reference Photo

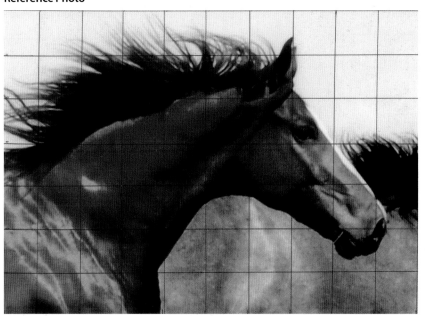

1 CREATE AN ACCURATE LINE DRAWING

Use the grid method to capture an accurate line drawing of the horse. When you like the look of your drawing, remove the grid lines with a kneaded eraser.

2 ESTABLISH THE DARK TONES

Once the grid lines have been removed from your drawing paper, establish the darkest areas with Black. These will be under the horse, along the lower edge of the face and neck, and in the base of the mane.

3 LAYER THE UNDERTONE AND BEGIN THE BACKGROUND

Base in the undertone of the horse with a light application of Orange. With Terra Cotta, create the patterns of muscles and contours of the horse's body. Where the light heavily reflects off the shoulder of the horse, it resembles the ripples seen in a moving body of water. Use Terra Cotta to build the dark areas here and add color to the mane.

Start the blue background from the top and work down, carefully layering Non-Photo Blue. Allow the blue to outline the horse's face, especially where there is the white blaze down the front of its head and nose. Use True Blue around the area of the nose and continue the color down to the lower edge. The sky gently fades from light to dark as it moves down the paper.

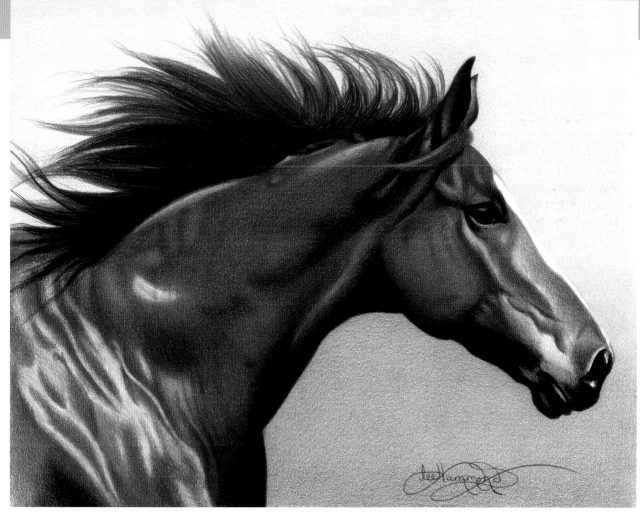

4 DEEPEN THE COLORS AND FINISH THE BACKGROUND

The final stages of the drawing will take some time because the entire drawing is layered, not burnished. Use Tuscan Red for the darker areas—the contours of form and muscle—and Dark Umber and Black for the darkest shadows. Because you are using the layering process, you should still be able to see the Orange undertones. Keep a sharp point on your pencils so the tones remain smooth and transitional.

Build the color and density of the mane with quick strokes. Start at the base of the mane and allow the pencil strokes to taper at the ends to enhance the appearance of individual hairs. Make sure your pencils lines follow the direction of the mane. Build the light colors, alternating Orange and Terra Cotta. Alternate Tuscan Red and Black for the darker colors.

Finish building the color of the sky with True Blue and Non-Photo Blue. Again, keep a very sharp point at all times to ensure the background has an even tone.

THINGS TO REMEMBER

- White isn't white and black isn't black—both colors are neutral and reflective in nature.

- When building fur color, make sure your pencil lines follow the direction that the fur flows to create texture.

- Consider using suede board when drawing animals—it gives fur a smooth, realistic appearance.

- To create realistic-looking hair, make sure to taper pencil lines at the end.

- Keeping a very sharp point on your pencil will ensure the background has an even tone.

10 People

Nothing is more rewarding than capturing the people you love in your very own work of art. Of all the types of art that I do, I love looking at the portraits I have created of my family members the most.

I recommend reading my book, *Lifelike Portraits from Photographs*, to use as a guide. It goes into much more detail, and is excellent for learning how to draw professional portraits. Enlarge your favorite photos on a color copier. This makes it easier to see the details and use the grid method.

Tell a Story With a Colored Pencil Portrait

Adding a person to your artwork can change your art from a simple drawing of objects to one that actually tells a story. This drawing has a wonderful story to tell: my granddaughter, Taylor, experiencing a close encounter with a butterfly at the zoo.

This is also a great example of art that includes a lot of color, both in the foreground and background. I chose to create the background out of focus to make Taylor stand out. It appears more as a grouping of light and dark green shapes, with little or no detail.

To achieve this blurry look, I heavily burnished the background. I also burnished the bright colors of her sundress and the butterfly. However, I used a light layering approach to give her face the look of childlike soft skin.

Taylor and the Butterfly
#1008 Ivory mat board
16" × 20" (41cm × 51cm)

demonstration

When teaching facial features, I always begin with the nose. It is the perfect first step when learning to draw faces because it involves a sphere and the five elements of shading.

MATERIALS

paper
Stonehenge

colors
Seashell Pink, Carmine Red, Dark Brown, Black

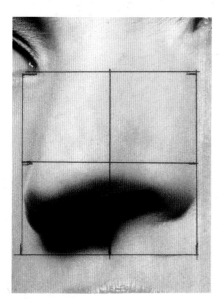

Reference Photo
Study the five elements of shading on this close-up photo of a nose. Notice the obvious cast shadows and reflected light, just like a sphere. Use the grid method to draw the nose, then carefully remove the grid lines with a kneaded eraser.

1 DEFINE THE DARKS AND CAST SHADOWS

Define the darkest areas of the nose using Dark Brown and the layering approach. Keep a sharp point on your pencil. Leave the reflected light around both of the nostrils, along the tip of the nose, and along the edges. Create the cast shadow of the right side of the nostril on the right, and under the nose.

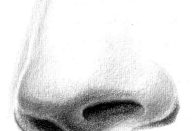

2 LAYER THE HALF TONES

With Seashell Pink, layer in the half tones of the skin. Make sure you don't lose the areas of reflected light. With the Dark Brown, deepen the shadow areas. With Black, fill in the nostrils, making it very dark under the nostrils' edges, and allowing the tone to lighten as it moves down.

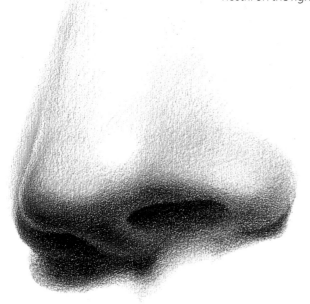

3 DEEPEN THE TONES

Layer Carmine Red over the Dark Brown shadow areas to warm the skin tone. Extend the Carmine Red beyond the Dark Brown, allowing it to softly fade into the Seashell Pink.

MATERIALS

paper
Stonehenge

colors
Chocolate, Dark Umber, Peach, Carmine Red, Black Raspberry, White

Mouths and teeth are very important in creating the likeness of a person. The lips and each tooth must be exactly the right size, shape, placement and color, or it won't look like the person you are trying to represent. These exercises will give you some valuable practice. But don't stop here—get out the magazines and keep practicing!

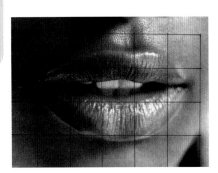

Reference Photo

Study the subject's complexion and subtle color changes in the lips. Use the grid method to draw the mouth, then carefully remove the grid lines with a kneaded eraser.

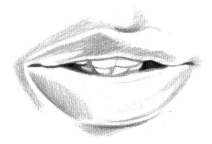
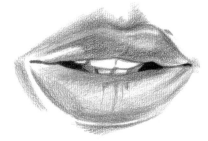
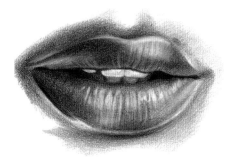

1 DEFINE THE DARKS AND CAST SHADOWS

Fill in the dark areas within the corners of the mouth with Dark Umber. Lightly edge around the teeth to create their shapes. *Do not* use a hard outline. With teeth, a dark line represents space between, and usually teeth touch each other.

Continue applying Dark Umber with a sharp point to the shadow edge of the upper lip, to the cast shadow below the lower lip, and just above the edge of the lower lip. Leave the areas of reflected light alone. Add more Dark Umber to the corner of the mouth on the right side, and to the indentation above the upper lip.

With Chocolate and a sharp point, apply tones to the left side of the mouth. Add a small amount to the right side of the lower lip as well, leaving an area of reflected light.

2 CREATE THE TONES

Add Peach to the upper lip. Layer into the reflected light area along the edge of the lip, leaving the highlight the white of the paper.

Add some Peach to the top of the lower lip, but be careful not to fill in the reflected light along the bottom edge. With Carmine Red, add some color to the bottom lip. This color is concentrated along the upper and bottom edges of the lip. Add a small amount of Black Raspberry to the right side of the upper lip, and use this color to create the center creases of the lower lip. Add some shadow to the lower teeth with Chocolate. Note that the teeth on the outside edges are darker since they are farther inside the mouth.

3 DEEPEN THE TONES

Deepen all the tones with the layering approach. Burnish White into the teeth, using a little bit of Chocolate to keep them looking natural. Add shadows to the lower teeth with some Peach.

Use White to burnish in the highlight areas and reflected light around the lips. Create the creases of the lips by burnishing White over the other colors with a firm touch. Do not overdo this detail because it will make the lips look aged.

Practice drawing a mouth viewed from the side. Create the line drawing using the grid method then erase all the grid lines with a kneaded eraser.

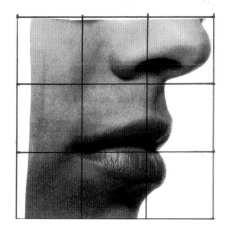

Reference Photo

MATERIALS

paper
Stonehenge

colors
Peach, Chocolate, Dark Umber, Sienna Brown, Henna, White

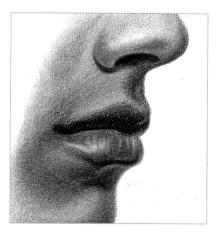

1 CREATE THE DARK SHADOWS

With Dark Umber, create all the shadow areas of the nose and mouth. Notice the small, comma-like shape in the corner of the mouth. This is called the "pit," and it is very important. It makes the mouth look recessed and three-dimensional.

2 BUILD TONE AND CREATE HIGHLIGHTS

Add Peach to the nose area above the upper lip and into the lower lip. Leave the areas of the highlights alone, allowing the white of the paper to show.

3 DEEPEN THE TONES AND SHADOWS

Build the complexion with the layering approach. Using Chocolate and a sharp point, lightly create the shadow of the cheek along the left side of the nose. Also use this color to create the shadow edge along the side and edge of the nostril. Be sure to leave the reflected light showing.

Deepen the shadow area between the nose and the mouth. Add Chocolate to the upper lip and into the small shadow above the corner of the mouth.

Using Henna, build the color along the lower side of the mouth and the rounded area of the chin. Leave the fullest part of the lips lighter in tone, with the Peach color exposed. Finish the drawing by carefully burnishing the highlights of the lip with White.

MATERIALS

paper
Stonehenge

colors
Dark Brown, Peach, Tuscan Red, Carmine Red, White

Some students tell me that drawing the ear is the most confusing aspect of drawing a portrait. This is because most of us don't pay much attention to this complex feature. The ear is made of many interlocking shapes, and the best way to get used to drawing it is to practice over and over. Commit the anatomy of the ears to memory—the more you draw, the better you will get!

Reference Photo

Using the grid method, sketch an accurate line drawing of the reference photo. Carefully remove the grid lines using a kneaded eraser.

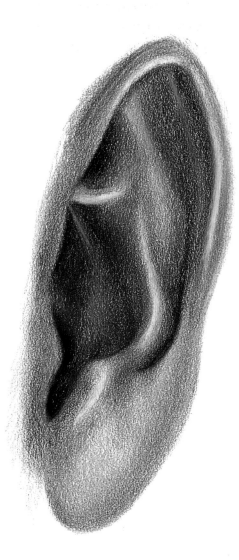

1 CREATE THE EDGES AND UNDERTONE

Lightly fill in the ear with a layer of Dark Brown. Try to view the ear as a series of unique shapes, and just focus on the shadow areas and overlapping cartilage.

2 CONTINUE LAYERING AND ADD THE SHADOWS

Develop the overall skin tone with a light layer of Peach. With Dark Brown deepen the shadow areas. Make sure to leave some of the paper showing for the highlight areas.

3 DEEPEN THE TONES AND BURNISH THE HIGHLIGHTS

Add Carmine Red to the edges of the ear and along the ear lobe. Also add this color to the inside of the ear along the right side.

With Tuscan Red, deepen the colors of the recessed, shadow areas of the ear, and burnish White into the highlights.

draw eyes

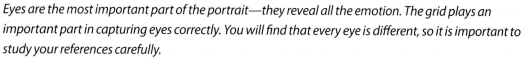

Eyes are the most important part of the portrait—they reveal all the emotion. The grid plays an important part in capturing eyes correctly. You will find that every eye is different, so it is important to study your references carefully.

When drawing eyes at an angle, the perfect circles of the irises and pupils turn into ellipses instead (circles in perspective). However, always center the pupil inside the circle of the iris for front-view portraits. The iris is nature's perfect circle, so use a template to ensure the accuracy of these shapes.

Eyes are moist and reflective, so there is always at least one highlight reflected. No matter how many highlights your photo reference shows, reduce it to just one. Place the highlight halfway in the pupil and halfway in the iris, so it does not affect the gaze of the eye.

MATERIALS

paper
Stonehenge

colors
Artichoke, Black, White, Dark Brown, Peach, Henna, Seashell Pink

Reference Photo
Use the grid method to achieve a line drawing. Be particularly careful with the irises and pupil, and take special note of the tilt of the eyes. When you are happy with your subject, remove the grid lines with a kneaded eraser.

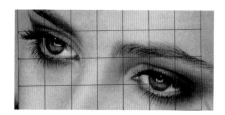

1 BURNISH THE IRIS AND PUPIL, CREATE THE EYELIDS

Burnish the entire iris with Artichoke. With Black, burnish the pupil completely, except for the small dot that represents the highlight or catchlight.

With Black, outline the outer edge of the iris and streak some into the iris to create the line pattern that exists in the irises of many eyes.

With White, burnish directly around the pupil. Avoid burnishing over the pupil's reflected light. Burnish the catchlight with White.

Using Black and a light touch, create the crease of the eyelid and the upper and lower lash lines. With Dark Brown, create the shapes of the eyebrows. Notice that on the lower lash line there is a shelf or ridge created by the thickness of the lower lid directly below the iris. The lashes grow out of the lowest edge. This lower lid thickness is essential when drawing eyes. With Peach and a sharp point, layer the skin color around the eye area, including the lower lid thickness.

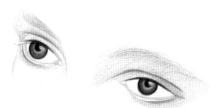

2 CONTINUE TO LAYER THE SKIN TONES AND SHADOWS

Deepen the skin tone around the eyes with Henna. Add this color into the corner membranes. Notice the ridge of reflected light above the eyelid crease of the right eye.

With Seashell Pink, add a slight shadow to the eyeball in the corners. Also add it below the eye on the left to enhance the look of roundness.

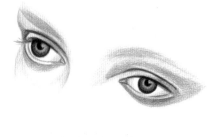

3 DEEPEN THE SKIN TONES, ADD THE EYEBROWS AND LASHES

Continue to build the color of the skin tone. Use quick strokes with Black to create the eyebrows and eyelashes, tapering the pencil stroke at the end. Study the length and direction of the different types of hairs, and practice drawing them on a separate piece of paper. It requires a very short, quick stroke to make the line taper at the end. Keep a very sharp point on your pencil, especially for the short, sparse lower lashes.

drawing hair

You saw in the previous exercise how important the pencil line is to creating eyelashes and eyebrows. It is the same with drawing hair. The pencil lines represent the length of the hair, and they must be drawn in accordingly.

It is very important to establish the skin tones of the face before beginning on the hair. The skin will show through the hair and around the hairline.

Study these close-up examples. You can see how they were created by applying different types of pencil strokes.

Close-up Study of Curly, Dark Hair

To create this type of hair, use your pencil "on the flat" and very small, light, circular strokes. The hair is much thicker in the middle of the scalp, and becomes less dense toward the outer edge where it meets the face. Begin with the lightest color, then layer on top with darker tones.

Colors Used
Terra Cotta, Black

Close-up Study of Long, Dark Hair

To create long hair, make long, quick strokes in the direction that the hair grows. Strive to taper your pencil lines at the end of each strand. Because hair is multi-colored, work from light to dark as you are adding the tones to make it look realistic. The dark tones will reinforce the shadows of the layers of hair and the curls. Repeat many applications of color, layer after layer, to build volume. Hair is made up of thousands and thousands of hair strands—it is impossible to create the look of thick hair with only twenty or thirty pencil strokes!

Colors Used
Peach, Terra Cotta, Dark Brown, Sky Blue Light, Black, White

Close-up Study of Short, Gray Hair

Hair grows in layers that overlap to create patterns. With wavy hair, each area has both light and dark areas, and it must be built up with multiple pencil strokes. Study this example, and you can see how the dark pencil strokes are placed on top of light pencil strokes to create these patterns.

Colors Used
Cool Grey 70%, Cool Grey 50%, French Grey 70%, White

Close-up Study of the Band of Light

Long, shiny hair has a band of light that reflects the light source along the curve of the head. This is where the roundness of the head is illuminated much like the full-light area of a sphere. Leave the highlight area the white of the paper and build layers of color around it from light to dark until it looks thick and smooth. Find more detail on creating blonde hair on pages 136–139.

Colors Used
Dark Brown, Goldenrod, Sand, Canary Yellow, Light Umber, White

skin tones

The paper you use can help you create realistic skin tones. If you are drawing a rosy-cheeked baby, select a pale pink paper. If you are drawing a darker complexion, choose a deep peach or brown paper to enhance the natural skin tones. Before you begin, you must decide what your ultimate goal is, and figure out the best way to achieve it.

Enhance Skin Tones With Colored Paper

The color of Martin Luther King Jr.'s skin is enhanced by the peach-toned drawing board. Some of the board shows through the drawing, enhancing the rich tones. I used many layers of Black in the background to make the portrait pop from the page.

I created his hair using the side of my pencil with tight, circular strokes. This technique makes the hair look full and richly textured.

Combine Techniques in Portraitures

I love this portrait of Ray Charles because of the many rich colors. Notice the combination of artistic methods, from the circular strokes depicting his hair to the reflective color and light used to show dimension. Combining effects is a good way to achieve realism in your work. Remember, portraiture requires practice, skill and, above all, time!

IMPORTANT

You must obtain permission to sell works of art that depict famous people or celebrities. Always obtain the advice of a copyright attorney before attempting to sell or distribute this type of artwork.

skin complexion value scale

There are many colors that make up skin tones and complexions. The following are some color combinations that may be used. However, these are just guides. Many combinations can be made since skin color is highly affected by light, shadows and color reflections.

Each of these tones was created by overlapping five colors, each listed from dark to light. Remember, these are just suggestions. Experiment with various colors to see what other combinations you can use to create skin tones.

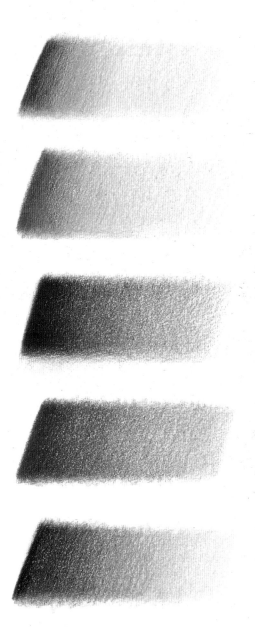

Light Complexion, Cool

Composed of Tuscan Red, Hot Pink, Pink, Blush Pink and Light Peach

Light Complexion, Warm

Composed of Henna, Poppy Red, Peach, Blush Pink and Sand

Dark Complexion, Cool

Composed of Dark Brown, Dark Purple, Tuscan Red, Henna and Peach

Dark Complexion, Warm

Composed of Dark Brown, Terra Cotta, Sienna Brown, Henna and Peach

Brown Complexion

Composed of Dark Umber, Dark Brown, Chocolate, Peach Beige and French Grey 10%

demonstration
draw a portrait

MATERIALS

paper
Stonehenge

colors
Seashell Pink, Peach, Henna, Black Raspberry, Dark Brown, Goldenrod, Canary Yellow, Light Umber, Apple Green, Grass Green, Dark Green, True Blue, Denim Blue, Black, White

Now that you have had some practice drawing the individual facial features and skin tones, let's try a portrait!

This is a photo I took of my daughter, LeAnne. I love the lighting of the outdoor setting, and the way the light and shadows play off her face. Use this graphed reference photo below as a guide for this portrait exercise.

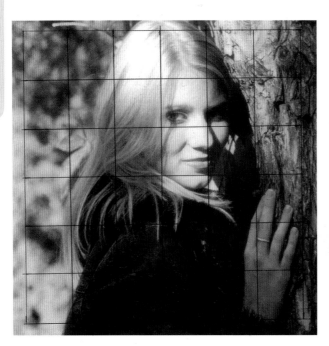

Reference Photo

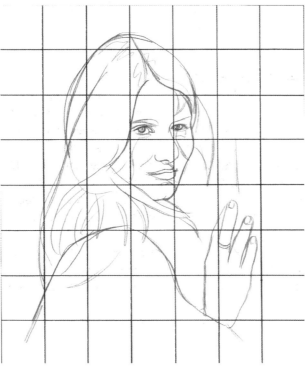

1 CREATE THE LINE DRAWING
Use the grid method to create an accurate line drawing of the reference photo. When you are happy with your sketch, carefully remove your grid with a kneaded eraser. Try to be as accurate as possible, because the entire outcome of your portrait hinges on this first step.

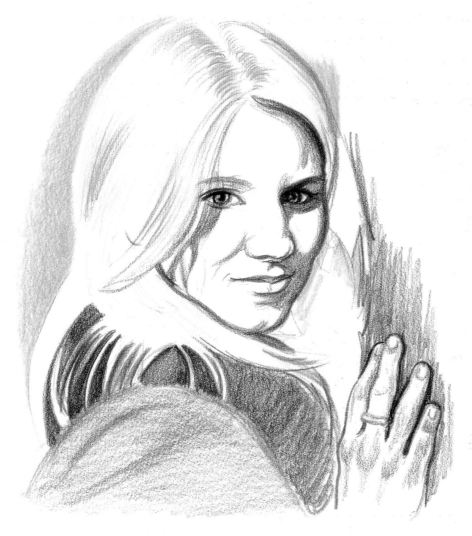

2 PLACE THE PORTRAIT'S UNDERTONES AND SHADOWS

Study the colors of the reference photo, and lightly place all the tones of the portrait. Lightly edge the intense shadows along the right side of the face with Dark Brown. Use this color along the jaw lines, under the hair on the right side and down the entire side of the face. Also with Dark Brown, create the shape of the eyebrows, the edges of the nose and the mouth. Gently fill in the dark shade of the upper lip.

With Black, create the shapes of the eyes, irises and pupils. Do not fill in the iris yet. Also with Black, lightly fill in the collar of the jacket and edge along the fingers and hand, placing some tone into the tree bark.

Use Black Raspberry to create the shapes of the shadows on the face along the right side, and also where the hair casts a shadow on the left side of the face. Then add some of the shadows to the hand. These shadows create the dimension and form of the face.

Add Canary Yellow to the hair, deliberately leaving the band of light untouched. Pull the hair strands out in long strokes and in the same direction. With Goldenrod, add the dark tones on both sides of the part with shorter strokes. You should be able to detect the individual hair strands; this enhances the look of realistic texture.

Use True Blue and a light touch to begin the tones of the denim jacket. Begin to layer the background's undertone with Apple Green.

3 DEEPEN THE TONES AND CREATE THE FORM

To build the skin tone, add Peach to both the face and the hand. On the hand, use an even layer of color over the entire area, overlapping the color already there. On the face, make the color deeper on the left side along the jaw by layering, keeping your pencil point sharp at all times. Overlap the Black Raspberry already there, allowing the colors to merge together. You should begin to see the sphere exercises in the cheeks, the nose and the chin.

With Henna, add some color to the lower lip, and to the cast shadow of the hair below the eye on the left. Add Henna to the creases under the eyes as well.

Deepen the color of the hair by adding more Canary Yellow. While you're there, add a little to the background, just to the right side of the face. Create the darker areas of the hair with Light Umber using long, quick strokes to replicate the hair's texture. For the deeper shadow area on the right side, add some layers of Dark Brown.

To create the fuzzy texture of the collar, use your pencil on the flat, and build the color with both Black and Dark Brown using small, circular strokes. It is identical to the way I created the dark, curly hair on page 132.

Create more texture in the tree bark between the fingers and above the hand using Dark Brown and Black.

To create the look of creases and folds in the jacket, add Denim Blue to the shadow areas. You may recognize the interlocking fold from page 62.

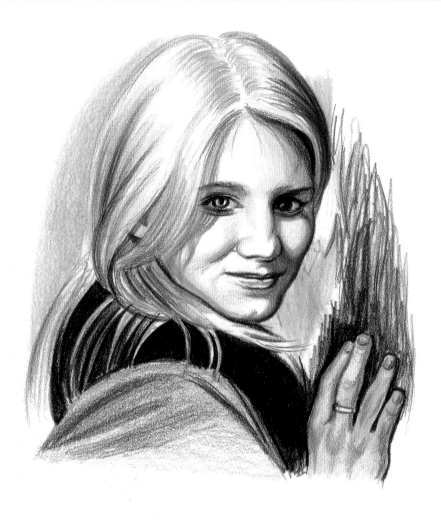

THINGS TO REMEMBER

- The lips and each tooth must be exactly the right size, shape, placement and color, or it won't look like the person you're trying to represent.
- Enlarge photos on a color copier so you can see details and use the grid method more easily.
- The "pit" is the comma-like shape in the corner of the mouth. It makes the mouth look recessed and three-dimensional.
- Eyes are the most important part of a portrait because they reveal emotion.
- The iris is nature's perfect circle, so use a template to ensure the accuracy of these shapes.
- Establish skin tones on a face before drawing hair.
- You must obtain permission to sell works of art that depict famous people.

4 DEEPEN ALL THE COLORS AND TONES TO FINISH

Use more Henna to deepen the corners of the eyes and add more color to the lips. Use Seashell Pink to shadow the eyeballs for roundness. Also add Seashell Pink to the area between the nose and the mouth to soften the edges of the shadows, allowing it to fade into the white of the paper. Add Denim Blue to the irises to create the eye color.

Use Seashell Pink to soften and transition the colors of the skin on the hand. Create the ring with Black and White, burnishing the colors for the look of shiny silver.

Burnish the highlight areas of the hair with White, and add White to the tips of the hair for shine. To warm up the hair tones, streak a little bit of Henna into it in the shadow areas under the ear, where it overlaps the face, and on the outside edge of the head on the right side.

Create the look of tree bark with harsh, heavy pencil lines. It is exactly like the examples on pages 45 and 67. Overlap colors to give the illusion of texture. Add some Goldenrod for a warm color, then continue to build texture with Dark Brown and Black. Burnish in some White for the highlights.

Using the layered approach, continue to build the blue tones of the denim jacket with True Blue and Denim Blue. In the deepest shadow areas of the interlocking fold, use Black. Finish the collar with more layers of circular strokes in Black and Dark Brown.

Create the illusion of leaves by adding subtle leaf shapes along the right side of the face using Grass Green and Dark Green. The subtlety of leaves will keep from overwhelming the portrait with a busy background. Add shadows behind the left side of the head using Grass Green to add depth.

A True Masterpiece

Sometimes a piece of art has just the right combination of color, shapes, composition and mood that qualifies it as a true masterpiece. For me, this is one of those pieces. Personally, this is a very meaningful portrait of my grandmother, sitting in her favorite chair in the apartment that I remember so well as a child. Every item represented in this drawing evokes a very emotional memory for me. It tugs at my heart every time I look at it—it perfectly captures my grandma the way I remember her, making it seem like it was just yesterday that I was right there with her.

At Grandma's House
Look at the variety of textures, repeated tones, complementary colors and techniques used in this piece of art.

Conclusion

There clearly were not enough pages in this book, because I could go on and on and on. But, as they say, all good things must come to an end! While this may be the end of another Lee Hammond book, it should not be the end of your practice. The projects in this book are just the beginning for you. Continue enjoying the wonderful world of colored pencil. Scour magazines, books and most of all, your own photo albums for interesting subjects to draw and create amazing compositions using your trusty viewfinders. You just never know when something will inspire you!

I'll leave you with one of my favorite sayings: "There is never a lack of subject matter—just absence of creativity!"

Have fun!

Sonny Denbow and His Cat
Stonehenge paper
11" × 14" (28cm × 36cm)

Index